时间是艺术-马雅20个太阳图腾图文手绘涂色本

Time Is Art—Mayan 20 Solar Seals and Wavespells Colouring Book

Esrah

PARTRIDGE

Copyright © 2019 by Esrah.

ISBN: Hardcover 978-1-5437-4993-9
 Softcover 978-1-5437-4992-2
 eBook 978-1-5437-4994-6

All rights reserved. No part of this book may be used or reproduced by any means, graphic, electronic, or mechanical, including photocopying, recording, taping or by any information storage retrieval system without the written permission of the author except in the case of brief quotations embodied in critical articles and reviews.

Because of the dynamic nature of the Internet, any web addresses or links contained in this book may have changed since publication and may no longer be valid. The views expressed in this work are solely those of the author and do not necessarily reflect the views of the publisher, and the publisher hereby disclaims any responsibility for them.

Print information available on the last page.

To order additional copies of this book, contact
Toll Free 800 101 2657 (Singapore)
Toll Free 1 800 81 7340 (Malaysia)
orders.singapore@partridgepublishing.com

www.partridgepublishing.com/singapore

这本书献给我已故的母亲，
亲爱的蔡瑞琼女士。
**This book dedicate to my dearest late mother,
Madam Chua Chin Loi.**

对不起
请原谅我
谢谢你
我爱你
**I am sorry
Please forgive me
Thank you
I love you**

目录 Table of contents

0. 如何使用这一本书 How to use this book

1. 红龙 Red Dragon

 1.1 在无形中创造有形的世界，再从有形的世界中回归到无形的世界。
 Creating a tangible world invisibly, and returning from the tangible world to the invisible world.
 1.2 红龙绘图 Red Dragon illustration

2. 白风 White Wind

 2.1 我把这一份美送了给你，愿你把它传播出去。
 I sent this beauty to you, may you spread it out.
 2.2 白风绘图 White Wind illustration

3. 蓝夜 Blue Night

 3.1 内在就是一个八宝箱，想什么，有什么。
 Inside is an eight treasure chest, everything you want is accessible.
 3.2 蓝夜绘图 Blue Night illustration

4. 黄种子 Yellow Seed

 4.1 如果你连自己都不能信任，还有什么值得你去信任的。
 If you can't even trust yourself, there is no others thing worthy of your trust.
 4.2 黄种子绘图 Yellow Seed illustration

5. 红蛇 Red Serpent

 5.1 红蛇的爱来自于与天地舞动，用超强的生命力与热情舞起那一路的风景，让它成为生命中的布景。

1

The love of the red serpent comes from dancing with the heavens and the earth, and dancing along the scenery of the road with super vitality and enthusiasm, making it a setting in life.

5.2 红蛇绘图 Red Serpent illustration

6. 白世界桥 White World Bridger

6.1 你的肉体在三次元存在，你的精神体却是跨次元的，他可以多次的来回在不同的次元，也就是你们所谓的过去、现在、未来。

Your body exists in three dimensions, and your spiritual body is trans-dimensional, he can go back and forth in different dimensions many times, that is, what you call the past, present, and future.

6.2 白世界桥绘图 White World Bridger illustration

7. 蓝手 Blue Hand

7.1 一双手可以创造出很大的空间，这空间可以伸展到了宇宙，接受来自宇宙的恩典，再把这恩典分发出去。

A pair of hands can create a huge space that can be extended to the universe, accepting grace from the universe, and distributing this grace.

7.2 蓝手绘图 Blue Hand illustration

8. 黄星星 Yellow Star

8.1 如果它看见自己真正的美丽，它会知道无论是夜晚还是白天它的光都是在 闪耀。

If it sees its true beauty, it will know that its light is shining at night, or during the day.

8.2 黄星星绘图 Yellow Star illustration.

9. 红月 Red Moon

9.1 宇宙之水好比奔腾的溪流流进了大海，把一切都清理干净了，让他们回归大海去净化。
The water of the universe flows like a rushing stream into the sea, cleans everything up, and lets them return to the sea to purify.

9.2 红月绘图 Red Moon illustration

10. 白狗 White Dog

10.1 这是一个循环的宇宙，你就是我，我就是你，爱就是这样的流动。
This is a universe of circulation, you are me, and I am another you. And love is such a flow.

10.2 白狗绘图 White Dog illustration

11. 蓝猴 Blue Monkey

11.1 蓝猴的爱来自于觉察，觉察到玩乐的一刹那觉悟就发生了。
The blue monkey's love comes from the awareness, the awareness happened at the moment of play.

11.2 蓝猴绘图 Blue Monkey illustration

12. 黄人 Yellow Human

12.1 头脑来自于他人格我的决定，心来自灵魂我的决定，两者一起并用，智慧自然滋生。
The decision of the brain comes from the decision of our lower self, and the decision of the heart comes from the decision of the soul, when the two are used together, wisdom naturally breeds.

12.2 黄人绘图 Yellow Human illustration

13. 红天行者 Red Skywalker

13.1 红天行者的爱来自于穿越，穿越那时空，去连接每个不同面向和可能性的自己。
The love of the Red Skywalker comes from crossing and passing through the time and space, connecting all the different faces and possibilities of ourselves.

13.2 红天行者绘图 Red Skywalker illustration

14. 白巫师 White Wizard

14.1 他知道时间的秘密，他可以在时间的时空中呼风唤雨。
He knows the secret of time. He can manifest in time and space.

14.2 白巫师绘图 White Wizard illustration

15. 蓝鹰 Blue Eagle

15.1 更高维度的你在一个多重次元的世界，俯视着在低次元的你。
The higher dimension of you is in a world of multiple dimensions, overlooking you in low dimensions.

15.2 蓝鹰绘图 Blue Eagle illustration

16. 黄战士 Yellow Warrior

16.1 你呈现无数个面向，这些面向带给了你不同的领悟和智慧。
You present countless faces that bring you different insights and wisdom.

16.2 黄战士绘图 Yellow Warrior illustration

17. 红地球 Red Earth

17.1 你最终会发现你就是那运转的中心。
You will eventually find that you are the center of the rotation and operation.

17.2 红地球绘图 Red Earth illustration

18. 白镜 White Mirror

18.1 其实你就是那颗钻石。
In fact, you are the diamond.
18.2 白镜绘图 White Mirror illustration

19. 蓝风暴 Blue Storm

19.1 那是风暴最平静的地方,也是你最平静的地方。
That is the calmest place in the storm, and the place where you are the most calm.
19.2 蓝风暴绘图 Blue Storm illustration

20. 黄太阳 Yellow Sun

20.1 成为你自己的太阳,你才能够成为别人的太阳和世界的太阳。
Be your own sun and you will be the sun of others and the sun of the world.
20.2 黄太阳绘图 Yellow Sun illustration

21. Hunab Ku 银河中心

22. 20 个马雅太阳图腾 20 Mayan Solar Seals

23. 20 个波符 20 Wavespells

23.1　红龙波符 Red Dragon Wavespell
23.2　白巫师波符 White Wizard Wavespell
23.3　蓝手波符 Blue Hand Wavespell
23.4　黄太阳波符 Yellow Sun Wavespell
23.5　红天行者波符 Red Sky Walker Wavespell
23.6　白世界桥波符 White World Bridger Wavespell

23.7 蓝风暴波符 Blue Storm Wavespell
23.8 黄人波符 Yellow Human Wavespell
23.9 红蛇波符 Red Serpent Wavespell
23.10 白镜波符 White Mirror Wavespell
23.11 蓝猴波符 Blue Monkey Wavespell
23.12 黄种子波符 Yellow Seed Wavespell
23.13 红地球波符 Red Earth Wavespell
23.14 白狗波符 White Dog Wavespell
23.15 蓝夜波符 Blue Night Wavespell
23.16 黄战士波符 Yellow Warrior Wavespell
23.17 红月波符 Red Moon Wavespell
23.18 白风波符 White Wind Wavespell
23.19 蓝鹰波符 Blue Eagle Wavespell
23.20 黄星星波符 Yellow Star Wavespell

0. 如何使用这一本书 How to use this book

这一本书里的文字与画都是透过右脑去连接宇宙的智慧和讯息而写和画的，所以要理解它是要用你的右脑和心去感受和连接。

The text and illustrations in this book are written and drawn through the right brain to connect the wisdom and message of the universe, so in order to understand them, you need to use your right brain and heart to feel them and connect to them.

这本书是连接马雅 20 个图腾的能量而写和画的，每一个图腾配有一篇相应的文章和一张相应的图腾画。涂色有一定的规则要遵循，特定的图腾有特定的颜色，其余的可以自由涂色。特定的图腾颜色如下：

This book is written and drawn through channeling the energy of 20 Mayan Solar Seals. Each solar seal is accompanied by a corresponding article and a corresponding solar seal illustration. There are certain rules to follow for colouring. A specific solar seal has a specific colour, and the rest can be freely painted. The specific solar seal colours are as follow:

红色 Red	图腾 Solar Seals
	红龙 Red Dragon （存在 being, 诞生 Birth, 滋养 nurture）
	红蛇 Red Serpent （本能 instinct, 生命力 life force, 生存 survives）
	红月 Red Moon （流动 Flow，宇宙之水 Universal Water，净化 Purifies）

	红天行者 Red Sky Walker （觉醒 wakefulness，空间 space，探索 explores）
	红地球 Red Earth （共时性 synchronicity，导航 navigation，进化 evolves）

白色 White	图腾 Solar Seals
	白风 White Wind （呼吸 breath，精神 spirit，沟通 communicates）
	白世界桥 White World Bridger （死亡 death，机会 opportunity，均等 equalizes）
	白狗 White Dog （忠诚 loyalty，心 heart，爱 loves）
	白巫师 White Wizard （接收 receptivity、永恒 timelessness，魔法 enchants）
	白镜 White Mirror （秩序 order，无限 endlessness，反射 reflects）

蓝色 Blue	图腾 Solar Seals
	蓝夜 Blue Night （直觉 intuition, 丰盛 abundance, 梦想 dreams,）
	蓝手 Blue Hand （疗愈 healing, 实现 accomplishment, 知晓 knows）
	蓝猴 Blue Monkey （幻相 illusion, 魔术 magic, 游戏 plays）
	蓝鹰 Blue Eagle （心智 mind, 视野 vision, 创造 creates）
	蓝风暴 Blue Storm （能量 energy, 自我运生 self-generation, 催化 catalyzes）

黄色 Yellow	图腾 Solar Seals
	黄种子 Yellow Seed （觉察 awareness，开花 flowering，目标 targets）
	黄星星 Yellow Star (艺术 arts，优雅 elegance，美丽 beautifies)

	黄人 Yellow Human （智慧 wisdom，自由意志 free will，影响 influences）
	黄战士 Yellow Warrior (无惧 fearlessness，理解 intelligence，提问 questions)
	黄太阳 Yellow Sun （生命 life, 宇宙之火 universal fire, 开悟 enlightens）

1. 红龙 Red Dragon

红龙 Red Dragon

红龙的爱-在无形中创造有形的世界,再从有形的世界中回归到无形的世界。

Red Dragon's Love - Creating a tangible world invisibly, and returning from the tangible world to the invisible world.

红龙的爱来自那深深的连接,与源头的连接,深深的把宇宙原始与古老的因素都连接在一起了。我们通过这样子的连接来认识我们的存在,来认识我们与一切万物都连接在一起。

The love of the Red Dragon comes from the deep connection, the connection with the origin of the source; it deeply connects the primitive and ancient factors of the universe. We know our existence through such connections, to know our existence and being, to know that we are connecting with everything.

当红龙从深潭中飞出来,成了独立的个体,离开了妈妈的怀抱,随着一切万有在空中翱翔,它要找回的是自己,因为它离开了源头,离开了那滋养它、创造它的源头。

When the Red Dragon flew out of the deep pool, it became an independent individual, leaving the mother's arms. It soars in the sky together with everything to find it true self because it left the source that had nourished and created it.

从源头中分裂出来的它带着原始的爱来到了人间，让人们看到了源头的创造力，那来自天边无际的爱。它找寻的是那万有的一切。翻转了天地，越过了高山，只为找寻那源头。出自于爱，它要找回爱的源头，去想起它就是那创造的源头，它就是那爱的源头。

Split from the origin source, it came to the world with the primitive love, to show people the creativity of the origin source that comes from the boundless love of the heaven. It is looking for the origin source of everything. It is flipping the world and crossing the mountains, to look for the source of origin. Coming from love, it wants to get back to the source of love, to recall it is the creation of the origin source; it is the love of the source.

你来自的源头，它一直都在哪儿，从未离开过，它等待的是有一天你能真正的连接回它，明白到你原来跟它是一体的，原来是从未分开的。

You came from the source, where it has been, never left, it waits for the day you can really connect back to it, knowing that you were originally integrated with it, it has never been separated.

那时间只不过是一层层的薄纱，把你们分隔开来，让你以为那是一重高山把你们相隔离了。

That time is nothing more than a layer of tulle; it separates you from the origin source, misleading you to think that it is a mountain that separates you and your origin source.

当你连接回红龙，你连接回你自己，你知道你是谁，你知道你来的目的，你知道你就是一切万有，从未分开过。你的爱恨情仇原来都是把戏，让你认识真正的自己，让你找回你的源头，扩展你的源头。

When you connect back to the Red Dragon, you connect back to yourself, you know who you are, you know the purpose of your life,

you know that you are everything, and never separated from the origin source. Your love and hatreds are all tricks, to lead you to know the true self, to lead you back to your origin source and expand your origin source.

让爱把你带回来,让心把你引领回来。你知道一切都是爱,一切都是让你体验到你就是那爱的本身。你从未离开过爱,你只是无法连结到爱,无法连结到你的源头,你自己。

Let love bring you back and let the heart lead you back. You know that everything is love; everything is for you to experience that you are the love itself. You have never left love, you just can't connect to love, and you can't connect to your origin source, yourself.

这一切的体验是为了让爱更能被看得见。在无形中创造有形的世界,再从有形的世界中回归到无形的世界,一切等着你来开发。你的力量,看见你的力量,那开创的力量,就在你身上,源源不绝,从未离开过。无论是什么形式的开创,它都是充满了爱,充满了道,充满了力量,一切就在你心中,等待着你去领取它,开发它,发现它。

The experience of all this is to make love more visible. Create a tangible world invisibly, and return to the invisible world from the tangible world. Everything is waiting for you to develop. Your strength, seeing your strength, the power of creation, is on you, endlessly source, never left you. No matter what form of creation, it is full of love, full of Dao, full of power, everything is in your heart, waiting for you to collect it, develop it and discover it.

红龙 Red Dragon

红龙说，我来自遥远的东方，我带来原始的动力。连接我，你有源源不断的推动力。我从爱中来，也从爱中去。

Red Dragon said, I am from the Far East, and I bring the original force, if you connect to me, you will have an endless force. I come with love and I will go with love.

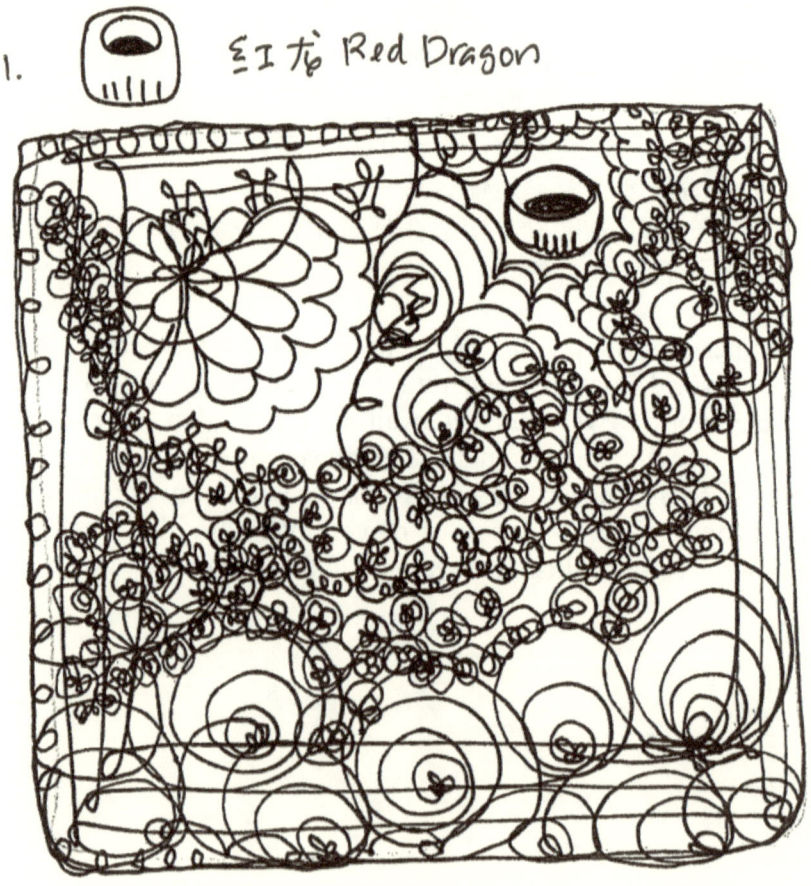

1. 红龙 Red Dragon

2. 白风 White Wind

白风 White Wind

我把这一份美送了给你，愿你把它传播出去。
I sent this beauty to you, may you spread it out.

白风的爱来自于那深深的体会，体会到人世间的冷暖，那冷暖来自于你的表达。当你是表达出你是冷的，人家就会感到是冷的，这世界就会变成是冷冰冰的。当你是表达出你是暖的，这世界就充满了阳光。阳光来自于内在你对爱的表达。

The love of the white wind comes from the deep experience of life, to experience the cold and warmth of the world, and the cold and warmth come from your expression. When you express that you are cold, people will feel cold, and the world will become cold. When you express that you are warm, the world is full of sunshine. Sunlight comes from your inner expression of love.

为什么会受到了阻挠？因为心里有了一层有一层的墙，让这风吹不进去，阳光出不来。

Why is the expression of love obstructed? Because there is a layer of wall in your heart, so that the wind can't blow in and the sun can't come out.

如何打开你的心墙，让里面的太阳可以把它的光洒出来，照暖你自己及这个世界。

How to break your heart wall so that the sun inside can sprinkle its light and warm yourself and the world.

白风会带领你去看到你的内在充塞了什么。从你的表达你知道你的内在有着什么。如果你的心被阴暗的空间占满，表达出来的必定是黑色的尘埃，如果你的心是被满满的阳光充满，表达出来的必定是满满的金光。金光带给你的是对这世界的爱，从你的心通过你的口表达出来，再通过你的手把它创造出来。

White wind will lead you to see what is inside you. From your expression you know what is inside you. If your heart is filled with dark space, the expression must be full of black dust. If your heart is filled with sunlight, the expression must be full of golden light. What Golden Light brings to you is the love of the world, expressed from your heart through your mouth, and then created through your hands.

白风就这样的一层层的螺旋包围着你，让你去体会这一切。藏在你心中的爱与恨，冷与暖，过去与未来的界限都在这里，因为爱会带领你去体会爱，恨会带领你去体会恨，它会像风一样的吹了出去，吹到世界的每一个角落，又吹回你的身边。它是属于你的，它会回到你身边，让你体会它，感受它，然后放掉它，像风一样的自由。

The white wind surrounds you with a layer of spiral, letting you experience all these. Love and hate, cold and warm, hidden in your heart, the boundaries between the past and the future are here, because love will lead you to experience love, hate will lead you to experience hate, it will blow out like the wind, blowing to every corner of the world and blowing back to you. It belongs to you, it will come back to you, let you experience it, feel it, and then let it go, like the freedom of the wind.

藉由风，你看到了世界，也看到了自己，看到你传播出去的是什么，你接收回来的是什么。你带着爱的呼吸，才能给这世界和暖的风，招来春天的花，开满了一树的果，让你看到了美丽的循环。

With the wind, you see the world and you see yourself, see what you are spreading out and what you are receiving. You have the breath of love, to give the world a warm wind, to attract spring flowers, to fill the fruit of a tree, and lead you to see the beautiful cycle of life.

我把这一份美送了给你，愿你把它传播出去。

I sent this beauty to you, may you spread it out.

白风 White Wind

白风说，我的心可以容纳一切，包括我自己，爱从我自己出发，飘到全世界。

White Wind said that my heart can accommodate everything, including myself. Love starts from myself and floats to the whole world.

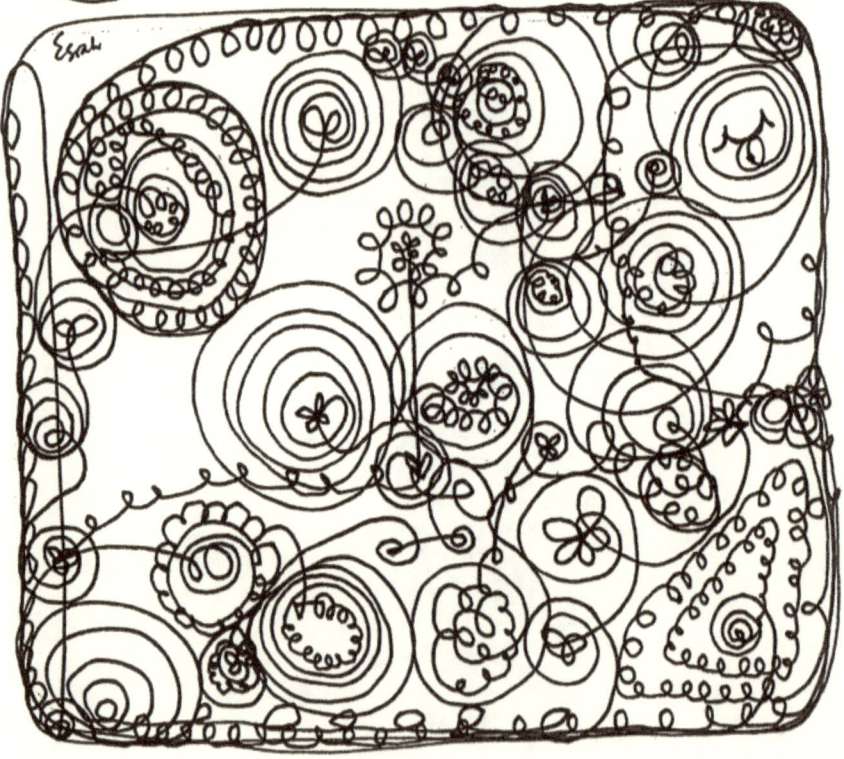

3. 蓝夜 Blue Night

蓝夜 Blue Night

内在就是一个八宝箱，想什么，有什么。
Inside is an eight treasure chest, everything you want is accessible.

蓝夜的爱来自于宁静，那一份深深的与内在自己的宁静连结。那个你敢于与自己梦想连结的自己，敢于拥抱自己梦想的自己，就在蓝夜中产生了。

The love of the blue night comes from the serenity, the deep connection with the inner self. The one you dare to connect with your dreams, the one who dares to embrace your dreams, is born in the blue night.

此刻的你不需要有太多的吵闹，只需要静静的与自己待在一起。内在就是一个八宝箱，想什么，有什么。你不需要大费周章的往外面寻找，你只要往内一掏，里面什么都有。

You don't need to have too much noise at this moment; you just need to stay with yourself quietly. Inside is an eight treasure chest, everything you want is accessible. You don't need to go outside and look for it. You just have to look inside and have everything inside.

只怕你不敢相信，不相信它的存在。只要你相信，它自然的就存在。但当你有了一丝的怀疑，它就会开始的溜走了。

I am afraid that you can't believe it and don't believe it exists. As long as you believe, it exists naturally. But when you have a suspicion, it will start to slip away.

无论你苦苦相守，如你未能守住对自己的信任，一切都是枉然的，像在黑夜中的风，不断的吹走。

No matter how hard you are to keep it, if you fail to hold on to your trust, everything is in vain, like the wind in the night, blowing away.

连结它，你连结到内在的丰盛；信任它，你把丰盛活了出来，像黑夜里的星星，闪闪发光，让你看到了夜的美丽，夜的丰盛。

Connect to it, you will connect to the inner abundance; if you trust it, you will live out the abundance, like the stars in the night, sparkling, you will see the beauty of the night and the abundance of the night.

那把钥匙就在你手上，等着你去开启它，发现它，信任它。它就是你一辈子的奴仆，为你服务，为你创造，为你使用。源源不绝的丰盛，一切就是那么的充裕，只要你去打开它，拥抱它。

The key is in your hand, waiting for you to activate it, find it and trust it. It will be the slave of you for life, serving you, creating for you. The resource is endless, everything is in abundance, as long as you activate it and embrace it.

这夜的美丽带领你进入最深的梦乡，与那源头的自己连结，回到它的怀抱，它的子宫，安安稳稳的睡着了。只要你持续与它连结，它会带你回去你的源头，丰盛的源头，宁静的源头。

The beauty of this night leads you into the deepest dream, connecting with the original source of yourself, returning to its, embrace in its uterus, and sleeping peacefully. As long as you continue to connect with it, it will take you back to your origin, the source of abundance and serenity.

爱你自己，信任你自己是连结的钥匙，就在黑夜中发现这一切。

Love yourself and trust yourself is the key to the connection, and discover all this in the night.

蓝夜 Blue Night

蓝夜说，宁静是我的本质， 宁静深邃的夜中包含了宇宙的一切， 我可以随手去截取我要的一切。

Blue Night said that tranquility is my essence. The quiet and deep night contains everything in the universe. I can easily intercept everything I want.

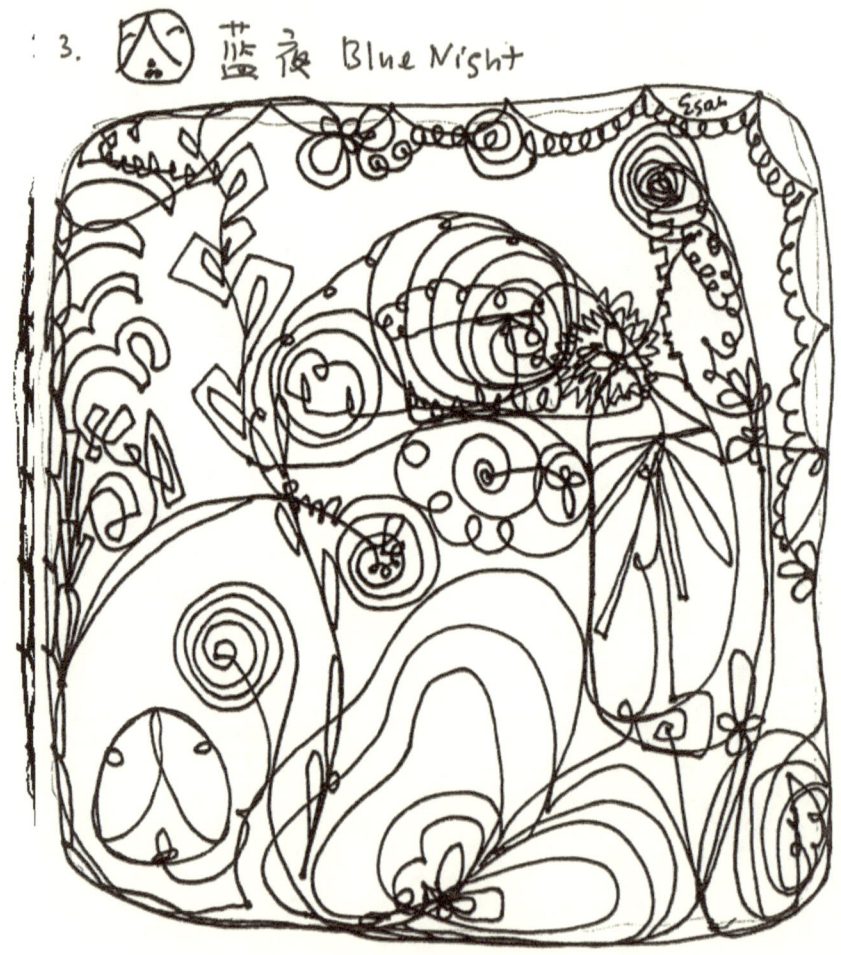

4. 黄种子 Yellow Seed

黄种子 Yellow Seed

如果你连自己都不能信任，还有什么值得你去信任的。
If you can't even trust yourself, there is nothing worthy of your trust.

黄种子的爱来自于觉知，觉知自己的美，自己的爱，自己的潜能。它在种子未长成树的之前已经可以看见自己的模样，没有一丝一豪的怀疑。所以，它总是可以在土里默默的等待，等待着这一天的到来。

The love of Yellow Seed comes from awareness, awareness of one's own beauty, one's own love, and one's own potential. It can already see its appearance before the seed grows into a tree, without any suspicion. Therefore, it can always wait silently in the soil, waiting for the arrival of this day.

它不会怀疑自己是否会在半途夭折，是否会长出不同的模样来，它对自己是百分百的信任，这信任会带领种子长成参天大树，开花结果，为路人创造巨大的遮阴天地，为自己树立一个爱的模样。

It will not doubt whether it will die halfway, whether it will grow differently. It is 100% trust for itself. This trust will lead the seed into a towering tree, blossoming and creating a huge cover for passers-by. Set a model of love for itself.

这就是种子，一个来自自己的信任，无论在什么的情况环境下，都不会对自己动摇。这一份力量带领它完成参天大树的结果，让它看见自己的美丽，让它看见自己的力量。这一份力量是爱的力量，是对自己爱的力量，是来自于相信自己的力量。

This is the seed, a trust from oneself, no matter what the circumstances, the trust will not shake. This power led it to become the towering tree, let it see its beauty, let it see its power. This power is the power of love, the power to love oneself, and the power to believe in oneself.

如果你连自己都不能信任，还有什么值得你去信任的，这就是种子要带来的讯息。

If you can't even trust yourself, there is nothing worthy of your trust. This is the message that the seed will bring.

黄种子 Yellow Seed

黄种子说，我在土里看见自己的无限，我看见蓝天，它就在我的上面，只要我破土，不断的延伸就能碰触它。

Yellow Seed said, I saw my infinity in the soil. I saw the blue sky above me. As long as I break the ground, I can touch it with constant extension.

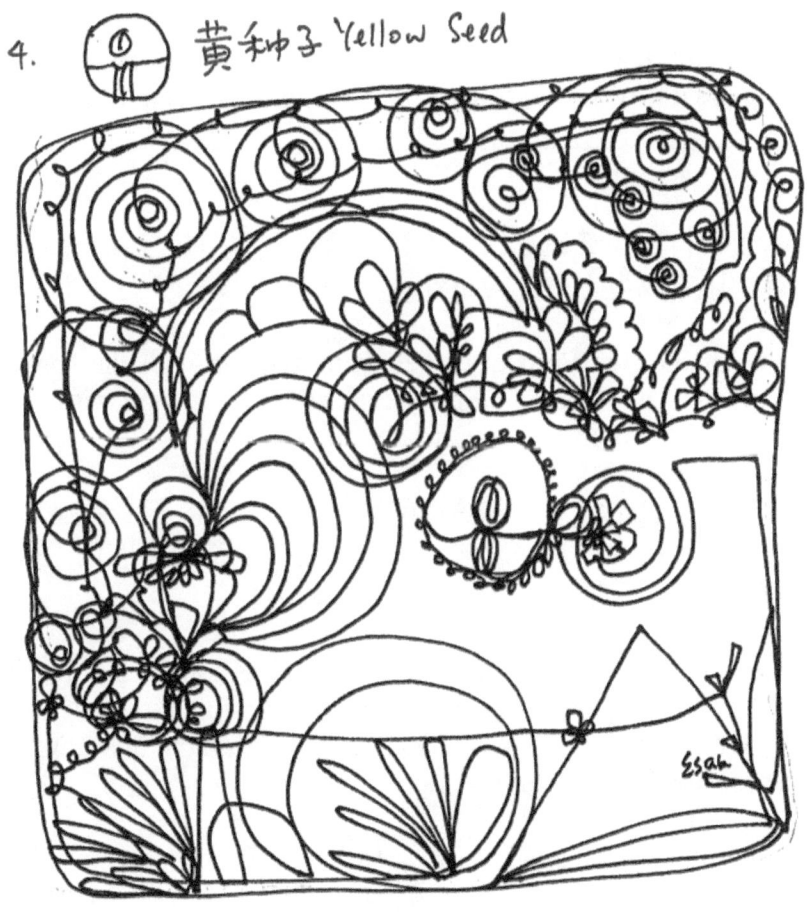

5. 红蛇 Red Serpent

红蛇 Red Serpent

红蛇的爱来自于与天地舞动，用超强的生命力与热情舞起那一路的风景，让它成为生命中的布景。
The love of the red serpent comes from dancing with the heavens and the earth, and dancing along the scenery of the road with super vitality and enthusiasm, making it a setting in life.

红蛇的爱来自于与天地舞动，用超强的生命力与热情舞起那一路的风景，让它成为生命中的布景。

The love of the Red Serpent comes from dancing with the heavens and the earth, and dancing along the scenery of the road with super vitality and enthusiasm, making it a setting in life.

红蛇的美丽来自于它对自己热情的爱，对于生活的爱，它从不厌倦舞动着那生命力，那是它的创造力，它为创造而特有的天分。当它舞动起来，天地的一切也会随之舞动起来。

The beauty of the Red Serpent comes from its passion for life. For the love of life, it never tires of dancing with vitality. It is its creativity, its unique talent for creation. As it dances, everything in the heavens and the earth will dance with it.

当你看见生命力，你看见了红蛇，你看见了自己的生命之流如何舞动。如果你的生命之流是无法舞动的，你无法为自己创造一个

流动的空间，你只能慵懒的困在一角，拥抱着无法流动的生命空间，死气沉沉。

When you see vitality, you see the Red Serpent; you see how your life stream dances. If your life is unmovable, you can't create a flowing space for yourself, you can only be lazy and sleepy, embracing the life space that can't flow, and you are dead.

让红蛇的生命力带动你，去舞动这世界的一切，包括你自己。随着红蛇舞动起来，你会看见生命之源源不绝的能量。

Let the vitality of the Red Serpent drive you to dance the world, including yourself. As the Red Serpent dances, you will see the endless energy of life.

搅动不止的能量处处显现，你也是其中之一。带领着你的是源源不绝的创造力，思想力与爱的流动。你只有在舞动的能量中才能看到这一股源源不绝的力量，发挥着你的动能。

You are one of them, where the energy that is stirring is everywhere. Leading you is the endless stream of creativity, the flow of thought and love. You can only see this endless power in the energy of dancing, and perform with your force.

红蛇 Red Serpent

红蛇说， 我来自天上， 我以我的速度在地上爬， 体验大地跟身体的接触， 体验在身体中找到爱。

The red snake said I am from heaven; I climbed on the ground at my speed, experienced the contact between the earth and the body, and experienced the love in the body.

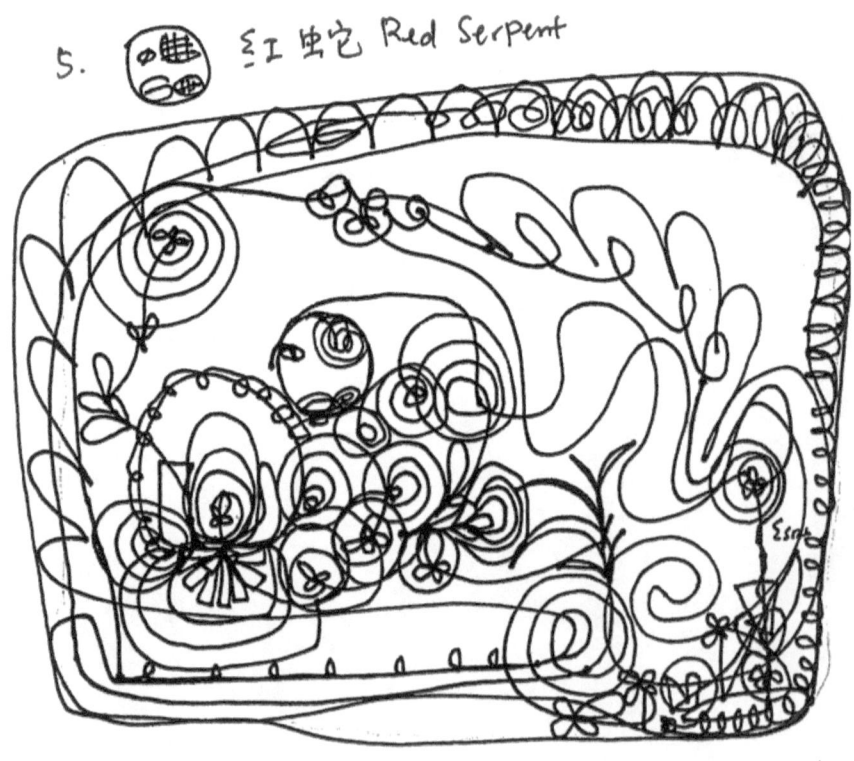

6. 白世界桥 White World Bridger

白世界桥 White World Bridger

你的肉体在三次元存在，你的精神体却是跨次元的，他可以多次的来回在不同的次元，也就是你们所谓的过去、现在、未来。
Your body exists in three dimensions, and your spiritual body is trans-dimensional，he can go back and forth in different dimensions many times, that is, what you call the past, present, and future.

白世界桥的爱来自于对跨次元的理解。这条桥把我们与不同次元的世界连接起来。我们本来就是一体，没有生没有死。为什么我们害怕死亡，因为我们不了解死亡背后的意义是要带给我们对这世界来源更多的了解。

The love of White World Bridger comes from the understanding of trans-dimension. This bridge connects us to the world of different dimensions. We are all one, no birth, no death. Why are we afraid of death because we don't understand the meaning behind death is to give us more insight into the origin source of the world.

死亡让你回到去了与你生命源头连接的部分，回到你诞生的部分，你明白这世界并不是只存有着一个次元。这是多重次元重叠的一个世界，你在这重叠的多次元世界找回你自己，连结回你自己，连结回你内在最真实的那一面，那一面是跨次元的。

Death leads you to go back to the part that is connected to your source of life, back to the part you were born, and you understand that the world is not just a single dimension. This is a world in which multiple dimensions overlapping. You find yourself in this overlapping multi-dimensional world, connect back to yourself, and link back to the innermost side of your inner side. That side is trans-dimensional.

你的肉体在三次元存在，你的精神体却是跨次元的，他可以多次的来回在不同的次元，也就是你们所谓的过去、现在、未来。你们以为那是一条直线，无法跨越次元去回头，但那是一个假象。透过这条桥你是可以回去过去未来的。生与死只不过是一个圈，转回来你又看得见了。

Your body exists in three dimensions, and your spiritual body is trans-dimensional. He can go back and forth in different dimensions, that is, what you call the past, present, and future. You think that it is a straight line, you can't go back through the dimension, but it is an illusion. Through this bridge you can go back to the past and to the future. Birth and death are just a circle, and you can see it again when you turn back.

白世界桥代表着你与自己的连接，当你可以与自己连接得很深，你也可以与这世界连接得很深。当你无法与自己连接时，你是无法与世界连接的，更不要说跨次元的连接。

White World Bridger represents your connection with yourself. When you can connect with yourself deeply, you can also connect with the world very deeply. When you can't connect with yourself, you can't connect to the world inclusive of connecting across dimensions.

连接自己最好的方法是进去内在看看，它在对你说什么，它想要连接的是什么？是世界上的财富地位吗？都不是，它想要连接的是这世界的时光网，它想与每一个时光网的光点连接，那是一个爱的连接。我们常常忽略了它，它想与世界一切万物的连接，因为它知道它们都是它的一部分。它想把爱带给这所有的自己，把它们连接起来，不再分离。

The best way to connect to yourself is to go inside and see what your heart try to tell you. What does it want to connect to? Is it the status of wealth in the world? No, it wants to connect to the world's time network, it wants to connect with the light spot of every time network, it is a love network. We often ignore it; it wants to connect with everything in the world because it knows that they are all part of it. It wants to bring love to all of them that are also part of you, connect them together, and no longer separate.

这个时光网连接到了宇宙的源头，也和宇宙的源头连接了起来。当万物回归合一时，一切就自然运生了，那就是和谐，你们一直寻找的和谐。

This time network is connected to the source of the universe. When everything returns to unity, everything will move naturally, and that is harmony, the harmony you have been looking for.

白世界桥 White World Bridger

白世界桥说，我是一个庞大的连接，天上地下都有我的存在，我用爱去连接，只有看见爱，才能连结到我。
White World Bridger said that I am a huge connection. I have my existence in the sky and the earth. I use love to connect. Only those with love can connect to me.

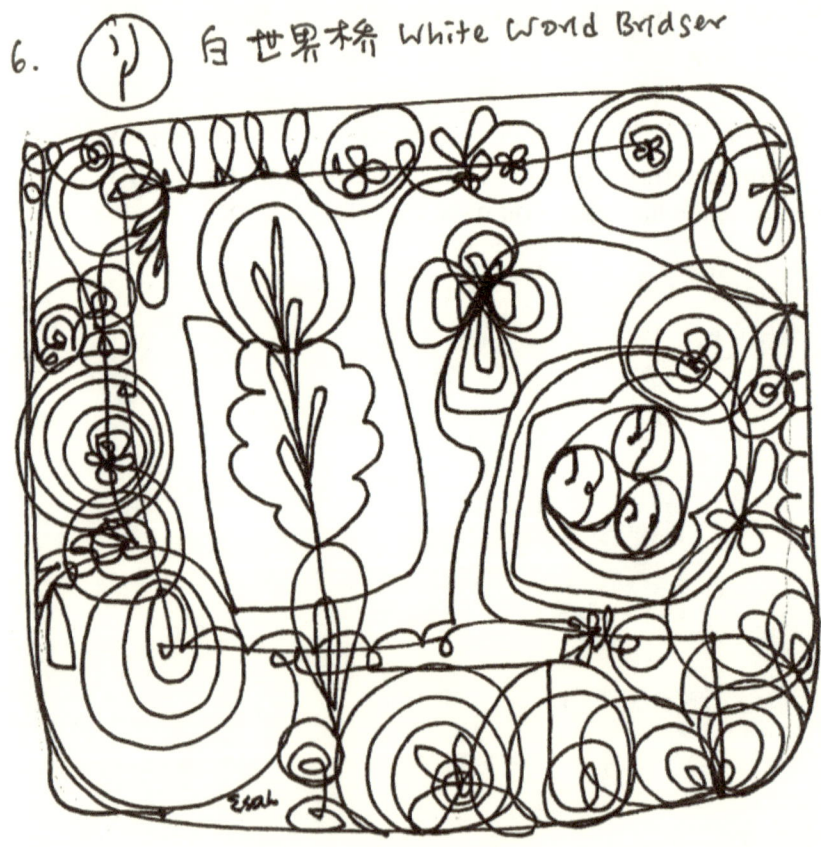

7. 蓝手 Blue Hand

蓝手 Blue Hand

一双手可以创造出很大的空间，这空间可以伸展到了宇宙，接受来自宇宙的恩典，再把这恩典分发出去。

A pair of hands can create a huge space that can be extended to the universe, accepting grace from the universe, and distributing this grace.

蓝手的爱来自于创作与疗愈。一双手抚慰着你的心，那是妈妈的手，抚哄着她的孩子入睡，带来了许多的疗愈。

Blue hand love comes from creation and healing. One hand soothes your heart that is the mother's hand, caressing her child to fall asleep, bringing a lot of healing.

一双手可以创造出很大的空间，这空间可以伸展到了宇宙，接受来自宇宙的恩典，再把这恩典分发出去。

A pair of hands can create a lot of space that can be extended to the universe, accepting grace from the universe, and distributing this grace.

这双手是对美丽的手，它可以做出许许多多的创造与疗愈，但它也可以做出许许多多的破坏与伤害。这取决于你如何去应用它，如何去赋予它生命力，你在掌控它还是任由它自由的去发挥。

These hands are beautiful hands, it can make a lot of creation and healing, but it can also cause a lot of damages and hurt. It depends on how you apply it, how to give it life, are you controlling it or let it play freely.

当你用你的意志力去掌控这双手，把它加注在别人的身上，它也失去了它的疗愈力。当你把自己的意图强加在别人的身上，回归你的是他人对你的不满与怨恨。

When you use your willpower to control the hands and raise it on others, it also loses its healing power. When you impose your intentions on others, it will cause the dissatisfaction and resentment of others.

你无法掌控这一切，包括你自己。你是自由的，你的灵魂知晓这一切，无论你外在包装的那么好，你好像在欺骗你自己。掌控让你失去了力量。

You can't control everything, including yourself. You are free, your soul knows. All of this, no matter how good you pretend, you seem to be cheating on yourself. Controlling makes you lose power.

了解自己的力量，连接自己的力量，你无法从掌控中获得力量，只有放手让一切东西回归到它自然的轨道，自然的运作，一切力量就会回到你的身上。你的疗愈力，你的创造力，让他们自然运生。

Know your strength, connect to your own strength, you can't gain strength from control, only when you let go of everything to return to its natural way, all power will return to you. Your healing power, your creativity, let them go naturally.

张开你手去迎接你的丰盛，来自创做的丰盛，它会带给你无穷无尽的乐趣。

Open your hand to meet your abundance, and create your own abundance, it will bring you endless fun.

蓝手 Blue Hand

蓝手说，我常常忽略了我该如何好好的看我自己，我用双手旋转舞动着上方的天空。只要我好好的关注我自己，我的手带着爱，我的手可以用来创造世间的一切。

Blue Hand said I often overlook how I should take good care of myself. I use my hands to rotate and move the sky above. As long as I pay attention to myself and with love, my hands can be used to create everything in the world.

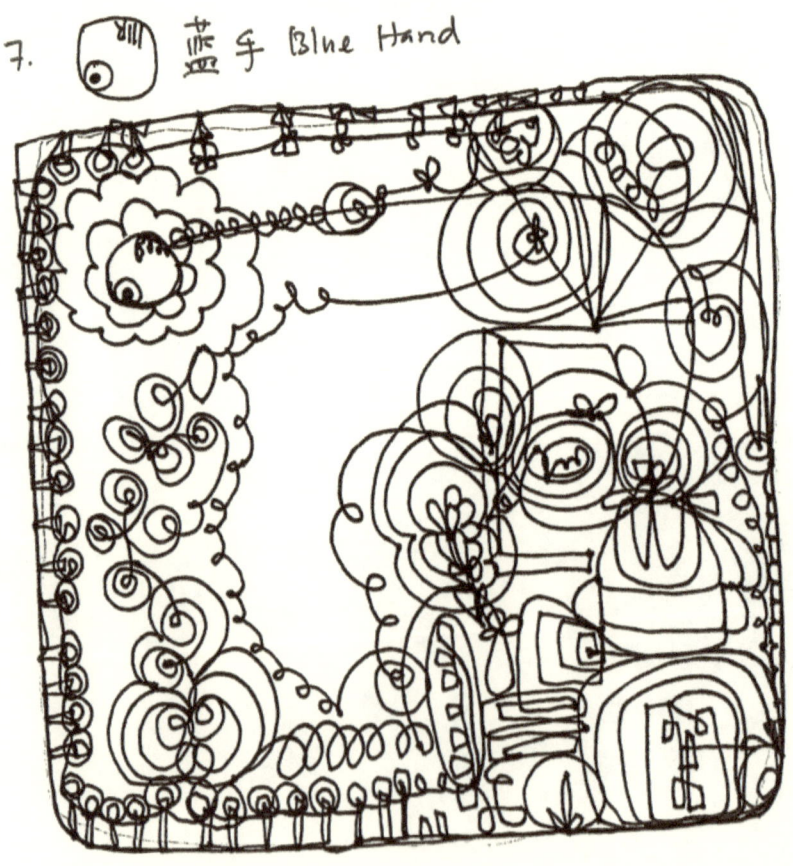

7. 蓝手 Blue Hand

8. 黄星星 Yellow Star

黄星星 Yellow Star

如果它看见自己真正的美丽，它会知道无论是夜晚还是白天它的光都是在闪耀。

If it sees its true beauty, it will know that its light is shining at night or during the day.

黄星星的爱来自于闪烁，在闪烁中看见自己的美丽和优雅。黄星星有着无比通透的光，这光能够照亮一片天地。不要以为这光是微不足道的，它可以带来很大的光芒。

The love of the Yellow Star comes from the flashing, seeing its beauty and elegance of oneself in the flash. The Yellow Star has an incomparably illuminate light that can illuminate the heaven and earth. Do not think that this light is insignificant; it can bring a lot of light.

星星高挂在夜的上空，你只有在夜晚看见它，它也以为它的光在夜晚才闪耀。其实如果它看见自己真正的美丽，它会知道无论是夜晚还是白天它的光都是在闪耀。这是因为它只想看见自己美丽的那一个部分，不想接受自己丑陋的那一面，所以它选择在晚上看见自己，没有阳光的衬托下它才能活出自己，只因它不想看见自己的缺点都被反射出来。

The stars are hanging high above in the sky at night. You only see it at night. It also thinks that its light only shines at night. In fact, if it sees its true beauty, it will know that its light is shining at night or during the day. This is because it only wants to see the beauty part of

itself, and does not want to accept its ugly side, so it chooses to see itself at night; it can live out itself with no sunlight, just because it does not want to see its own shortcomings reflected in the sun.

美与不美，丑与不丑都是它自己的感觉和假设，那并不是真实的一面。真正的星星是明白到自己的光无论在什么时候都在闪耀，它不需要阳光，也不需要黑夜来衬托它。它就是它，那美丽的星星，那闪耀的星星。

Beauty and not beauty, ugly and not ugly are their own feelings and judgment; it is not the real situation. The real star is to understand that its light is shining whenever it is, it does not need sunlight, and it does not need the night to set it off. It is itself, the beautiful stars, the shining stars.

黄星星

黄星星说，我看见世界的美，也看见自己的美，我用美去表达我的爱。

The stars said, I saw the beauty of the world, and I saw my beauty. I express my love with beauty.

8. 黄星星 Yellow Star

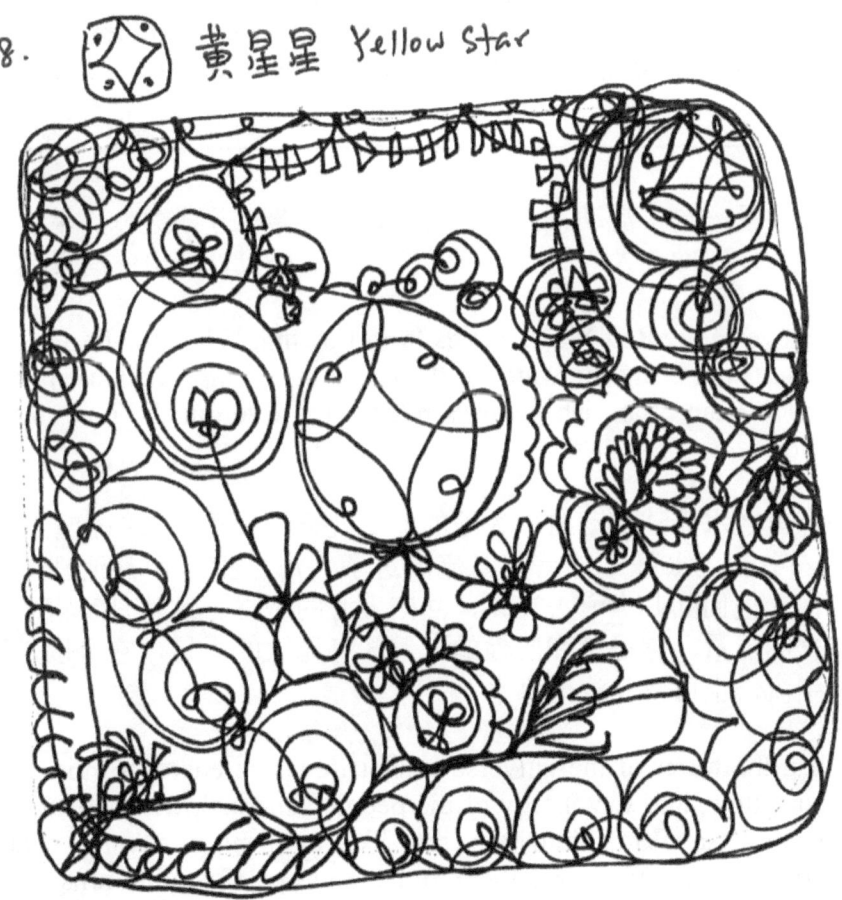

9. 红月 Red Moon

红月 Red Moon

宇宙之水好比奔腾的溪流流进了大海，把一切都清理干净了，让他们回归大海去净化。
The water of the universe flows like a rushing stream into the sea, cleans everything up, and lets them return to the sea to purify.

红月的爱来自于流动，当红月流动，它会带来宇宙之水，清洗这一片大地，冲洗人们的心灵，滋养人们的心灵，活出爱的天地。

The love of the Red Moon comes from flowing. When the Red Moon flows, it will bring the water of the universe, cleanse the land, purify people's hearts, nourish people's hearts, and live out the love in the world.

当宇宙之水无法流动时，大地的能量就无法流动，人们就无法流动。宇宙之水好比奔腾的溪流流进了大海，把一切都清理干净了，让他们回归大海去净化，回归大海的平静。这就是宇宙之水带来的能量，它是柔和阴性的，但却有无比的力量，它可以是涓涓细流，也可以是涛涛洪水。

When the water of the universe cannot flow, the energy of the earth cannot flow, and the energy of the people cannot flow. The water of the universe flows into the sea like a rushing stream, cleans everything up, and returns them to the sea to purify and returns to the calm of the sea. This is the energy brought by the water of the

universe. It is soft and yin in nature, but it has incomparable power. It can be a trickle or a storm.

你的抗拒有多大,它的力量就有多大。你的臣服有多大,它就能带你到多远。红月不止是涓涓细流,它也不止是涛涛洪水,它能带给你的还有更多更多。去连接它,从它那里获得讯息,你会看到涛涛不绝的流水就在你的眼前,带领你去走上无尽的人生路。

How big is your resistance, how big is its power. How big is your surrender, how far it can take you. The red moon is not only a trickle, it is not only a flood, and it can bring you more and more. Connect to it, get the message from it, you will see the flowing water in front of your eyes, leading you to the endless life path.

红月 Red Moon

红月说，我的流动让人们找到自己，那个与大海连结的自己。

Red Moon said that my flow allows people to find themselves, the ones who are connected to the sea.

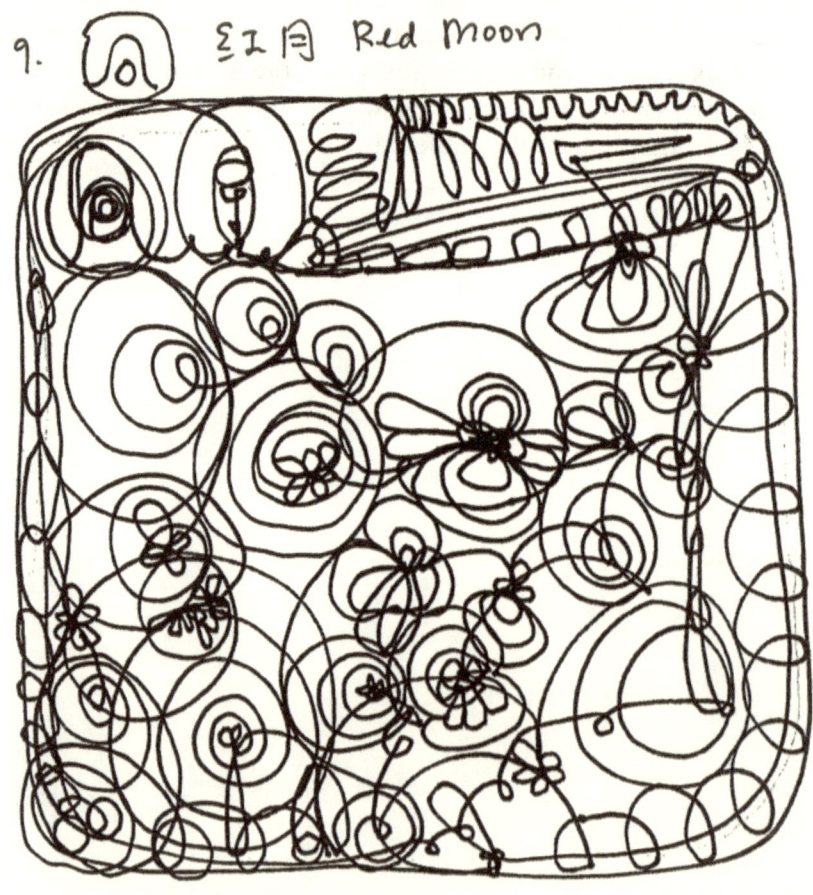

10. 白狗 White Dog

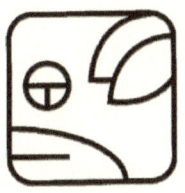

白狗 White Dog

这是一个循环的宇宙，你就是我，我就是你，爱就是这样的流动。

This is a universe of circulation, you are me, and I am another you. And loves is flowing in such way.

白狗的爱来自于臣服，臣服于自己也是爱，臣服于自己就是爱的一部分，它要看到自己就是那爱的本身后，它才能真心无条件的给与爱，活出爱。它不再祈求别人的回报，别人的关注，因为它知道爱的来源是它自己，它就是一个爱的中心，把爱源源不绝的散发出来。

White Dog's love comes from surrender, surrender to himself is also love, surrender to himself is part of love, it must see that he is the love itself, it can truly give love and live out love. It no longer looks for the rewards from others and seeks the attention form others, because it knows that the source of love is itself, it is the centre of love, the endless stream of love.

当它源源不绝的把爱散发出来后，这宇宙的空间就会充满了爱。那爱也会滋养回它。当它能够做到这一点的时候，整个宇宙都充满了爱，人们也充满了爱，因为它成了万物，万物也成了它。

When it projects endless stream of love, the space of this universe will be filled with love. That love will nourish it back. When it can do

this, the whole universe is full of love, and people are full of love, because it becomes everything, and everything becomes it.

这是一个循环的宇宙,你就是我,我就是你,爱就是这样的流动。

This is a universe of circulation, you are me, and I am another you. And love is flowing in such way.

白狗 White Dog

白狗说，我只想安静的在这里看着人群的流动，我希望他们都能爱自己，就好像我对他们的爱。
The White Dog said, I just want to be quiet here to watch the flow of people, I hope they can love themselves, just like my love for them.

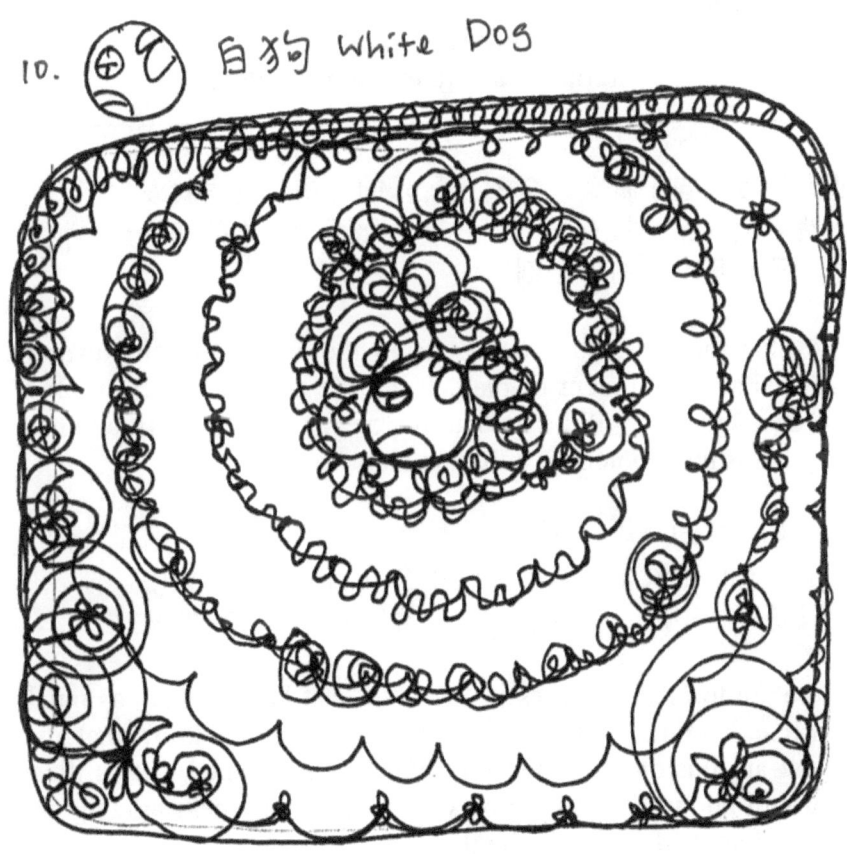

11. 蓝猴 Blue Monkey

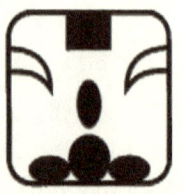

蓝猴 Blue Monkey

蓝猴的爱来自于觉察，觉察到玩乐的一刹那觉悟就发生了。
The blue monkey's love comes from the awareness, the awareness happens at the moment of play.

蓝猴的爱来自于觉察，觉察到玩乐的一刹那觉悟就发生了，它不用费多大的劲。只有当下那一刻，你回到了你的初心，尽情的玩乐，那就是觉悟的那一刻。

The blue monkey's love comes from the awareness, the awareness happens at the moment of play. It doesn't take much effort. Only at that moment, you will be back to the origin of your heart, and having fun, that is the moment of enlightenment.

人生有太多的游戏，你只要尽情去玩儿，主要你带着觉察的心，知道这一切都只是幻相，你就不会受困在这个幻相中，你会知道你只是幻相中的一个棋子，在走着你的人生游戏棋盘。

There are too many games in life. You just have to play as much as you like. You mainly have to be at the moment and know that all this is just an illusion, and then you will not be trapped in this illusion. You will know that you are only like a piece of chess moving on the board of your life game in the illusion.

棋盘中有你的父母、兄弟姐妹、，亲戚朋友，他们都在跟你一块玩儿，一块学习，编制着棋盘的梦，但这一切终究是一场空，棋

盘始终会结束，然后你又到了另一场棋盘，这就是你的人生轮回路。

There are your parents, brothers and sisters, relatives and friends on the chess board. They are all playing with you, learning together and compiling the chessboard dream, but all this will become empty, the board will always end, and then you will go to another chessboard, this is the incarnation of your life cycle.

它要你看清的是一切都在虚幻中学习和成长，没有什么是永久不变的。无论是多么美丽的情感，多么痛苦的创伤，多么远大的成就或挫败，它都只是虚幻中的一颗棋子，让你去明白宇宙中的道理，明白你自身的本质，牵引你去认识你是谁。所以这世间没有爱，也没有恨，没有平静，也没有喧闹，只有你自己。

It wants you to see that everything is a learning process and growing process in the illusion. Nothing is permanent. No matter how beautiful is the relationship, how painful is the wound, how great is the achievement or frustrations, it is only one of the illusory ones. A piece of chess that leads you to understand the truth in the universe, to get to know your own nature, and leads you to know who you are. So there is no love in this world, no hatred, no calm, no noise, only you.

你就是那一切，你就是爱的本身，你就是恨的本身。你就是那万有的一切，你就是那变的一切，你也是那不变的一切。你就是你自己的源头，一切事物的源头，那看见和看不见。一切的源头，就在那游戏中。

You are everything, you are the love, you are the hatred, you are the Oneness, you are everything of everything, and you are the changed and unchanged. You are your own source, the source of everything, the visible and the invisible. The source of everything is in that game.

蓝猴 Blue Monkey

蓝猴说，我看见一切的真相，所以我远远的站在这里，如如不动的看着这一切，我在我的世界中嘻戏，我也在人们的世界中嘻戏，我的爱就在当中。

The Blue Monkey said, I saw the truth of everything, so I stood here far away and look at it unmoved. I am playing in my world, I am also playing in people's world, and my love is in it.

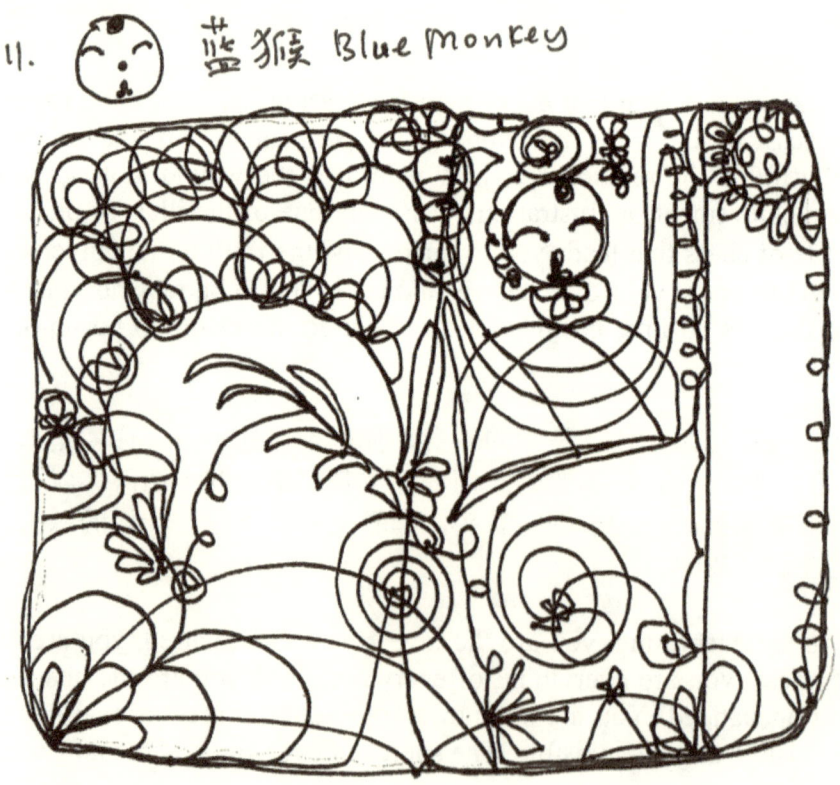

12. 黄人 Yellow Human

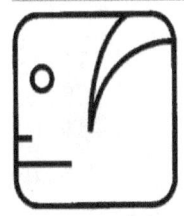

黄人 Yellow Human

头脑来自于他人格我的决定，心来自灵魂我的决定，两者一起并用，智慧自然滋生。
The decision of the brain comes from the decision of our lower self, and the decision of the heart comes from the decision of the soul, when the two are used together, wisdom naturally breeds.

黄人的爱来自于领悟，领悟到自己的自由意志来自于自己的智慧。他不需要寻寻觅觅，他只要知道一切就在他手中的自我选择，他可以选择愚昧的人生，也可以选择智慧的人生。只要他的选择是来自于他的心，他的智慧就会增长。

The love of the Yellow Human comes from realization, and realizes that his free will comes from his own wisdom. He doesn't need to keep on searching; he only needs to know that everything comes from the decisions in his hands. He can choose an ignorant life or a wisdom life. As long as his choice comes from his heart, his wisdom will grow.

他的心能告诉他一切，引领他做出智慧的选择。头脑和心都是他的武器，但他往往只记得使用他的头脑而忘了他的心，他只用头脑一再的分析，忘了用心感受同样重要。

His heart can tell him everything and lead him to make a wise choice. Brain and heart are his weapons, but he often only remembers to use

his brain and forgets his heart. He only uses his brain to analyze again and again, forgets the feeling with the heart is equally important.

头脑来自于他人格我的决定,心来自灵魂我的决定,两者一起并用,智慧自然滋生。你要学会用你的心去连接你的大脑,也要学会用你的大脑开启你的心,就是我们所谓的心电感应。这是我们在这新时空中不可缺的。两者是相辅相成的。为了在灵性上的成长,你要把他们连接起来供你使用,这样你才能更全面的去过你的人生,去呈现你原有的样貌。

The decision of the brain comes from the decision of our lower self, and the decision of the heart comes from the decision of the soul, when the two are used together, wisdom naturally breeds. You must learn to connect your brain with your heart, and learn to use your brain to activate your heart, which is what we call ESP (Extra Sensual Perception). This is indispensable to us in this new time and space. The two are complementary. In order to grow spiritually, you need to connect them for your use, so that you can live your life more comprehensively and perform your own nature.

黄人 Yellow Human

黄人说，我是天上的特使，我来传达人的讯息，让他们活在真理中，看见自己的强大。我总能穿越一切阻扰，回到我爱的中心。

Yellow Human said I am the special envoy of heaven. I will convey the message of the people, to lead them to live in the truth, and to see their own strength. I can always pass through all the obstacles and return to the centre of my love.

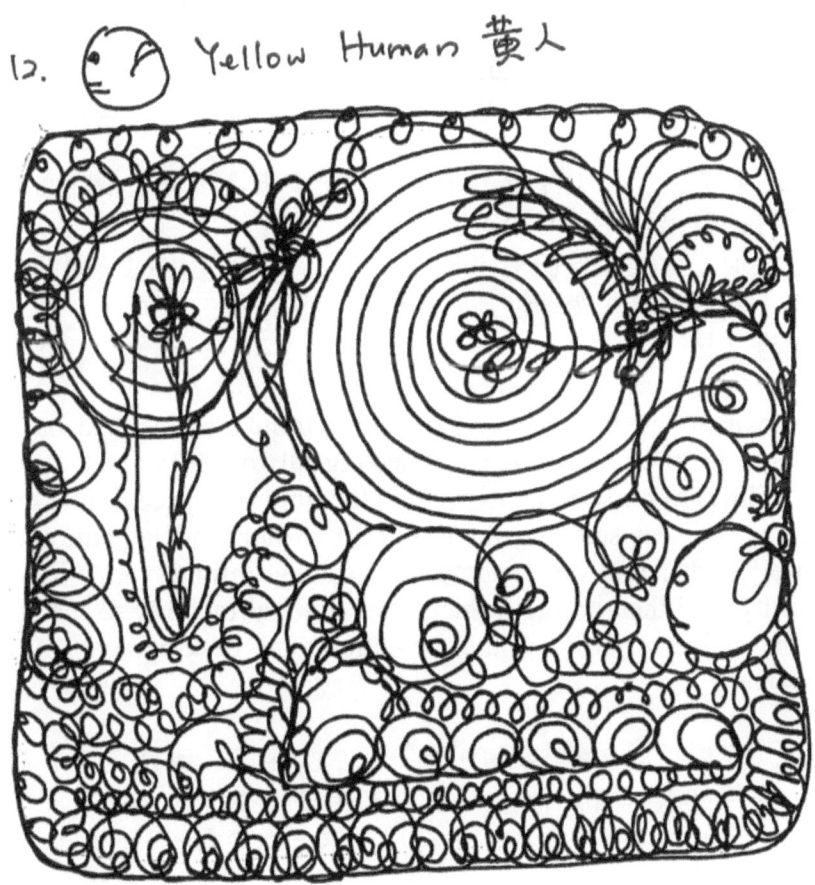

13. 红天行者 Red Skywalker

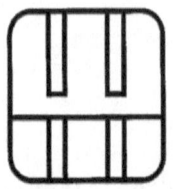

红天行者 Red Skywalker

红天行者的爱来自于穿越，穿越那时空，去连接每个不同面向和可能性的自己。
The love of the Red Skywalker comes from crossing and passing through the time and space, connecting all the different faces and possibilities of ourselves.

红天行者的爱来自于穿越，穿越那时空，去连接每个不同面向和可能性的自己。穿越时空中去寻找每一个不同的当下自己，然后去连接他，让他穿梭在不同时空的自己。带来无限的变动性与移动性，然后把这些变动性与移动性带来这宇宙的空间，带动这宇宙的进化与开展。

The love of the Red Skywalker comes from crossing and passing through the time and space, connecting all the different faces and possibilities of ourselves. Go through the time and space to find every different present self and then connect to him and let him shuttle himself in different time and space. Bringing infinite variability and mobility, and then bringing this variability and mobility to the space of the universe, driving the evolution and development of this universe.

我们的飞船就是以这样子的一个可能性存在，或许这不容易理解。连接红天行者，他会带领你去穿梭，在你的人生空间中穿梭，在宇宙的空间中穿梭。你会看到这一切源自于开创的自己。

Our spaceship exists in such a possibility that it may not be easy to understand. Connect with the Red Skywalker; he will lead you through the shuttle, shuttle in your space of life, shuttle in the space of the universe. You will see that it all comes from your creation.

红天行者 Red Skywalker

红天行者说，人们总是不停的往两边的墙框左右的跳，束缚在一个四方框框里，其实你可以往上空直飞出去，飞出了框框后，那是无边无际的宇宙上空。

The Red Skywalker said that people always keep jumping around the wall framed on both sides, and they are bound in a four-frame box. In fact, you can fly straight out into the sky. After flying out of the frame, it is the boundless universe.

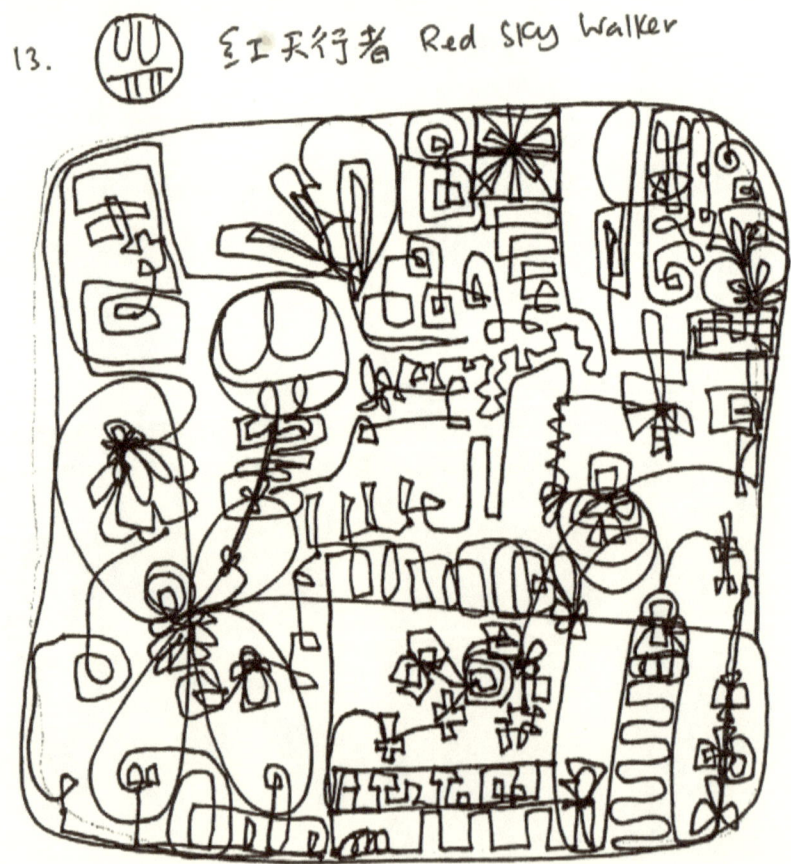

14. 白巫师 White Wizard

白巫师 White Wizard

他知道时间的秘密，他可以在时间的时空中呼风唤雨。
He knows the secret of time. He can manifest in time and space.

白巫师的爱来自于时间，就在他找到那永恒的那一刻，当下即是永恒，他知道时间的秘密，他可以在时间的时空中呼风唤雨。他知道那永恒的那一刻是他意识穿越的那一刻，当他的意识停留在那一个点，时间就静止了，他可以在这一个点回到了过去未来，去创造他想要的结果，只要他的意识能够穿越那三次元的频率。

The white wizard's love comes from time, just when he finds the eternal moment, the moment is eternal. He knows the secret of time. He can manifest in time and space. He knows that the moment of eternity is the moment when his consciousness breaks through. When his consciousness stays at that point, time is still. He can return to the past and future in this point to create the result he wants, as long as his consciousness can cross the frequency of the three dimensions.

那是一个时间隧道，他可以在里面自由走动，去创造他所要的东西，去变出他的魔法，他像风一样出现在任何的时空，去改写他的频率。当他能够去改写他的频率的时候，一切就变得有可能了，他可以穿越一切的时空。可是他首先必须穿越的是他的意识。要穿越意识首先他要看见自己的意识空间，这意识空间就存在他的能量场。

It was a time tunnel where he could move freely, to create what he wanted, and transform his magic. He appeared in any time and space

like the wind, to rewrite his frequency. When he can rewrite his frequency, everything becomes possible, and he can travel through all the time and space. But the first thing he must break through is his consciousness. To break through consciousness, he must first see his own space of consciousness, and this space of consciousness exists in his field of energy.

在他身体的每一个细胞的空隙，随着他心智的扩展，这些意识空间也在扩展，它可以扩展到无限大的空间，去连接每一个时空的万事万物，去停留在每一个万事万物的时空，把那时空停止，去看到自己与天地的无限大与空间。

In the gaps of every cell in his body, as his mind expands, these spaces of consciousness are expanding. It can be extended to infinite space to connect everything in every time and space, to stay in all the space and time. And stop the time and space, to see the infinite space of the world and of owns self.

在那空间包含着无数的自己。在意识频率上的改变能带领你去了解那永恒的空间，在时间停留的那一个空间，那是你看见永恒本我的空间。

There are countless self in that space. Variation in the frequency of consciousness can lead you to understand the eternal space, the space where the time stays, that is the space where you see the eternal self.

那空间包含你，保含我，包含一切万事万物。我们都不曾分离。你将体悟到，当你接触永恒的那一刻，你在连接你自己的同时你也在连接着万事万物，感受着万事万物，创造着万事万物。那就是你的本质，那个不变的你。

That space contains you, contains me, and contains everything. We have never been separated. You will realize that when you are exposed to eternal moments, you are connected to yourself while you are connected to everything, to feel everything, and to create everything. That is your own nature, the one that is eternity.

白巫师 White Wizard

白巫师说，我活在光的世界里，当你看清一切都是光，都是爱，你不再追赶什么，你能潇洒的在世间遨游人间。

The white wizard said I live in the world of light. When you see that everything is light and love, you are no longer chasing anything, you can play in the world.

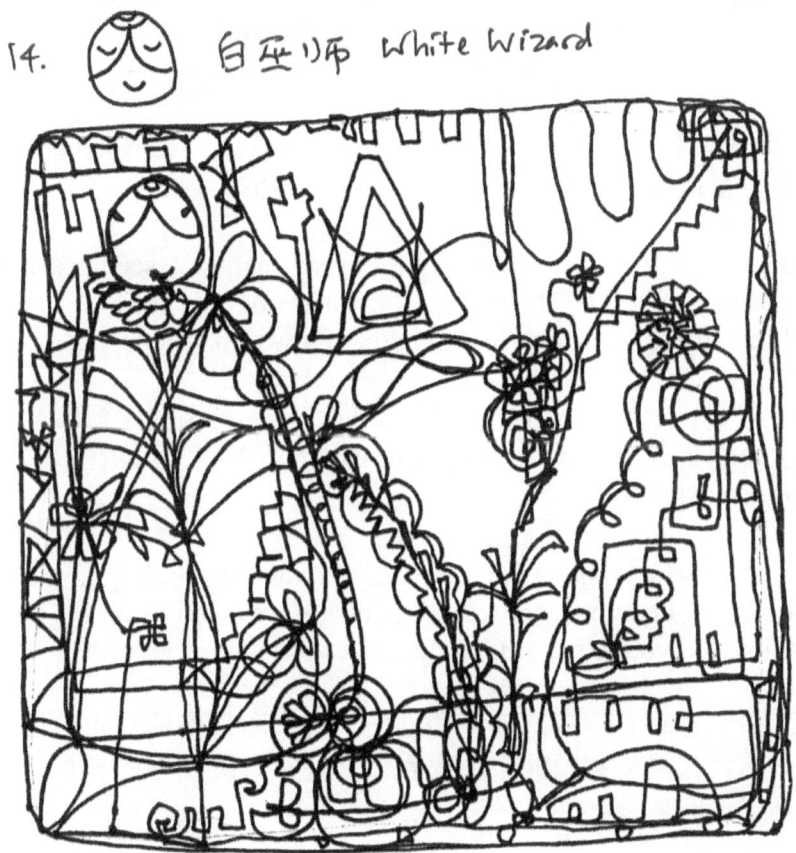

15. 蓝鹰 Blue Eagle

蓝鹰 Blue Eagle

更高维度的你在一个多重次元的世界，俯视着在低次元的你。

The higher dimension of you is in a world of multiple dimensions, overlooking you in low dimensions.

蓝鹰的爱来自于看见，看见更高维度的自己。更高维度的你在一个多重次元的世界，俯视着在低次元的你。

The love of the Blue Eagle comes from seeing, seeing a higher dimension of itself. The higher dimension of you is in a world of multiple dimensions, overlooking you in low dimensions.

他知道哪一个是真实的你。他看见你在时间的河流中流转，他知道这一切是为了什么，他要把这一切转化成爱，让你在爱的体验中看到你自己。

He knows which one is the true you. He saw you circling in the river of time. He knew what it was all about. He wanted to turn it all into love and led you to see yourself in the experience of love.

河流中或许有着许多的痛苦和创伤，也有着许多的欢乐与创造。这一切你都能用蓝鹰的眼睛去看。他能穿透幻相中的真相，让它转化成你的智慧。

There may be a lot of pains and traumas in the river, and there are a lot of joys and creations as well. All of this you can see with the eyes

of the Blue Eagle. He can penetrate the truth in the illusion and transform it into your wisdom.

当你迷茫时，借用它的眼睛，它会带领你站在更高的山坡看见整个大地，看见你的人生脉路。你在河流中不断的流转，直到一天你找到了自己。

When you are confused, borrow its eyes, it will lead you to a higher hillside to see the whole earth and see the path of your life. You keep on flowing in the river until you find yourself one day.

蓝鹰 Blue Eagle

蓝鹰说，即使在黑暗中我的眼仍像镭射一样，在高空中看清十万八千里的景物，我看见能量以螺旋的方式在旋转着，我带着爱去看待这一切，我变得更敏锐。

The Blue Eagle said that even in the darkness, my eyes are still like lasers. When I look at the scenery in the sky, I see the energy spinning in a spiral. I look at it with love, I become more acute.

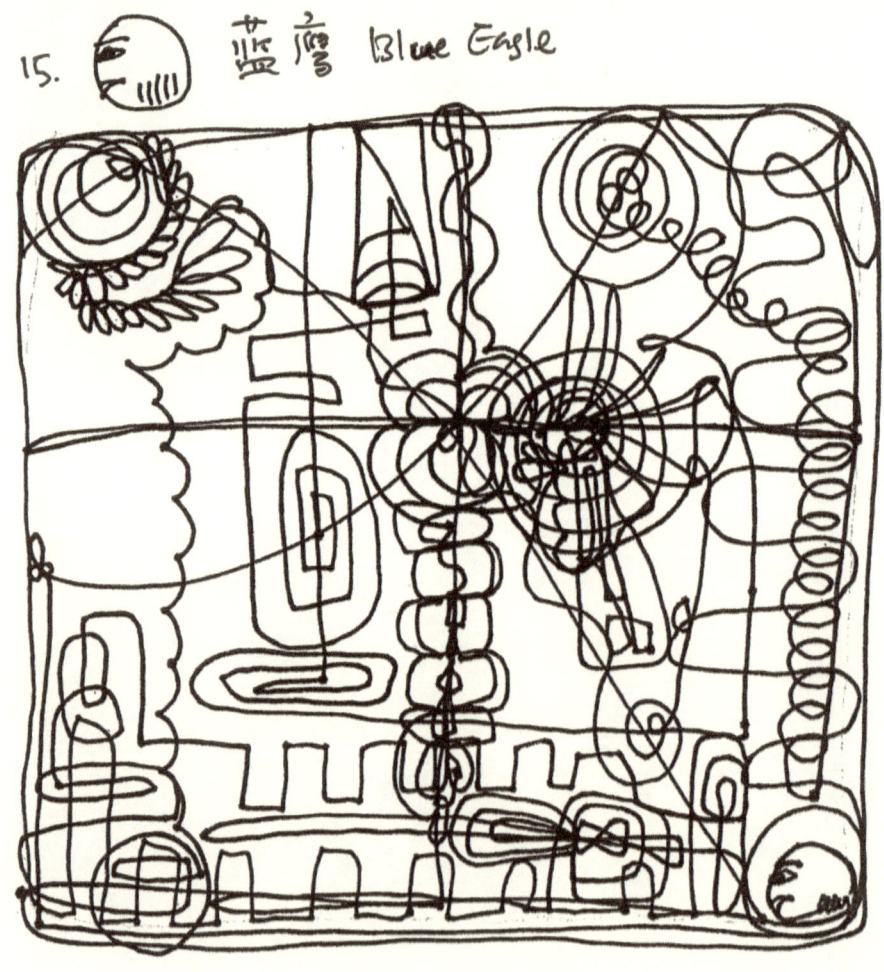

16. 黄战士 Yellow Warrior

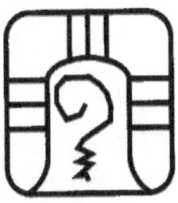

黄战士 Yellow Warrior

你呈现无数个面向，这些面向带给了你不同的领悟和智慧。

You present countless faces that bring you different insights and wisdom.

黄战士的爱来自于勇气；看见自己的勇气、创造自己的勇气、战胜自己的勇气。在无数个转世，你呈现无数个面向，这些面向带给了你不同的领悟和智慧。

The love of the Yellow Warrior comes from courage; seeing his own courage, creating his courage, and the courage to overcome his own self. In countless reincarnations, you present countless faces that bring you different insights and wisdom.

黄战士就是引领这些智慧的人，他会带你穿越你自己的黑暗面，走向智慧的光，这些光一直都在，只是你被小我的尘埃所遮蔽了，看不见这道光就在你的身上散发出来，也无法去接受它的指引。

The Yellow Warrior is the one who leads this wisdom. He will take you through your own darkness and toward the light of wisdom. The light is always there, but you are covered by the dust of the ego. You can't see this light in yours and cannot receive its guidance.

黄战士的剑能为你拨开一条路，引领你去看见自己的光，只要你有勇气去看见自己，看见自己黑暗的那一面。其实那也不是真正黑暗的那一面，它只是光背后的一些暗影，引领你去看见自己是个纯粹的光，是个能让宇宙发亮的光。

The sword of the Yellow Warrior can open a way for you to lead you to see your own light, as long as you have the courage to see yourself and see your inner darkness. In fact, it is not the real darkness. It is just some shadows behind the light. It leads you to see that it is a pure light, a light that can make the universe shine.

当这光陆陆续续在世界各地亮起来的时候，这就是一个充满光的世界。要看见光，你必定先要战胜内在的黑暗，打开光之门，让光照进来。这就是战士的能量。

When this light is shining around the world, there will be a world full of light. To see the light, you must first defeat the inner darkness, open the door of light, and let the light come in. This is the energy of the warrior.

黄战士 Yellow Warrior

黄战士说,我带着闪亮的光无畏的来到这里寻找真实的我。那个带着爱,带着光的我,不断的前进,通往一道螺旋的道路。我越过了螺旋的桥,来到了宇宙中心,看见了我。

The Yellow Warrior said that I came here with a shining light fearlessly to find the real me. The one with love and light, constantly moving forward, leading to a spiral path, I crossed the spiral bridge; I came to the centre of the universe and saw me.

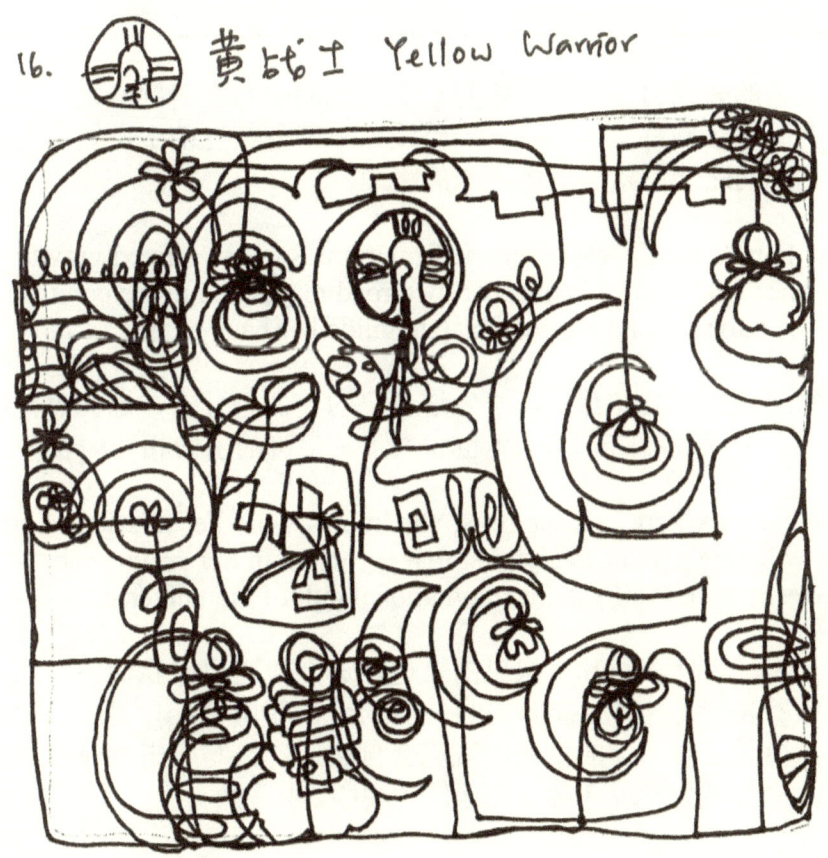

16. 黄战士 Yellow Warrior

17. 红地球 Red Earth

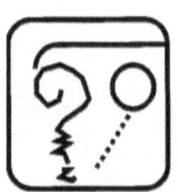

红地球 Red Earth

你最终会发现你就是那运转的中心。
You will eventually find that you are the centre of the rotation and operation.

红地球的爱来自于自转，她有一个固定的引力在引领着她，无论什么时候，她都会知道自己的路线图，即使在迷茫中，她始终会找到她的路线图指引着她回家的路途。

Red Earth's love comes from self rotation. She has a fixed gravity to lead her. She always knows her own road map, even in the confusion; she will always find her road map to guide her back home.

她知道她的中心在那里，她知道自己的使命是什么，她会照料在她引力中承载着的一切。她也和太阳及宇宙的引力相互动着。

She knows where her centre is, she knows what her mission is, and she will take care of everything that is carried in her gravity. She also moves with the sun and the gravitational pull of the universe.

每个人，每件事，都有自己的轨道。这个轨道也在我们的身上，引领着我们与地球、宇宙与自然界的运作和协调，只要我们跟着这韵律去运作，你的生命的流就会自然运转，与宇宙的流和谐一致。你最终会发现你就是那运转的中心。

Everyone, everything, has its own track. This track is also on us, leading us to operate and coordinate with the earth, the universe and the natural world. As long as we follow this rhythm, the flows of your life will work naturally and is in harmony with the flow of the universe. You will eventually find that you are the centre of the rotation and operation.

红地球 Red Earth

地球妈妈说,"孩子,我就在这里,你感受到我了吗?我就在你所看到的一切,所摸到的一切,所感受到的一切。只要你伸开手,我就在你的掌心,拥抱着你,滋养着你。"(张开手心,地球刹那出现围绕和拥抱着你,你就在她的中心)

Mother Earth said, "Child, I am here, can you feel me? I am everything you see, everything you feel, everything you touch. As long as you open your hand, I am in your palm, hug you, and nourish you." (Open the palm of your hand, the earth appears around and hugs you, you are at her centre)

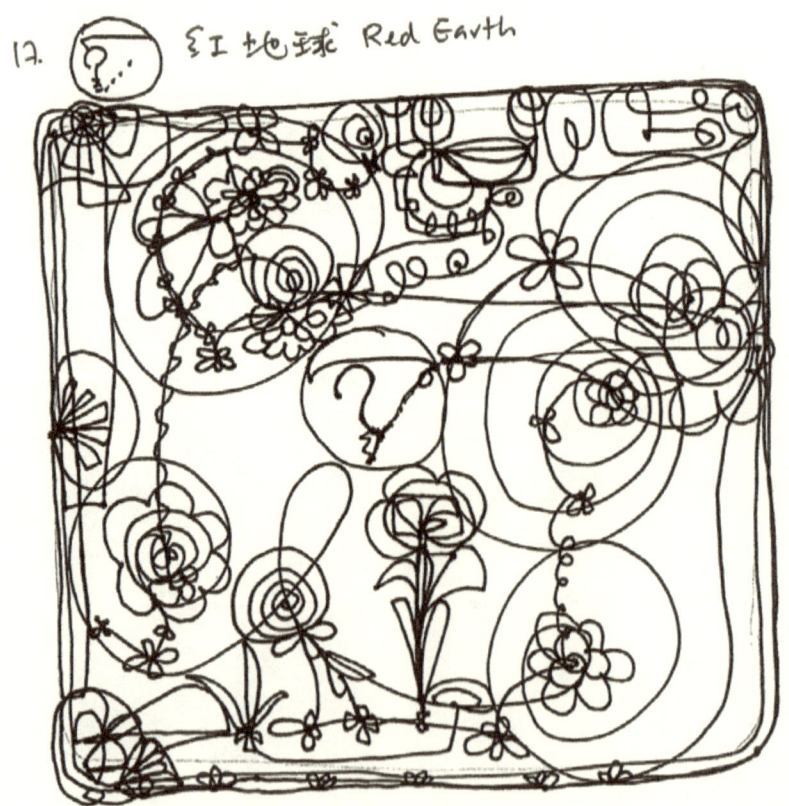

18. 白镜 White Mirror

白镜 White Mirror

其实你就是那颗钻石
In fact, you are the diamond

白镜的爱来自于投射，像一颗钻石投射出很多不同面向的自己。曾经你以为这一些面向都是你，你以为真实的你就是这些不同的面向。

The love of White Mirrors comes from projection, like a diamond projecting many different faces. Once you thought that these faces are all of you, you think that all these different faces are the real you.

其实你就是那颗钻石，你有着钻石通透美丽，你可以发出很多的折射，让你从中看清很多事情的不同面，如果你能够不迷惑于其中，你很快就会看到你的心就是那面镜子。

In fact, you are the diamond. You are like a diamond that is transparent and beautiful. You can make a lot of refractions, so that you can see the different faces of many things. If you are not confused by the refractions, you will soon see your heart. That is the mirror.

你所做出的评判，论断都来自于那心的折射。你以为这就是你，你以为你就是你那评判的自己，你没有看见自己就是那颗钻石。你一直往外去追逐，希望平息外在的一些评判，但你不知道真正的评判是来自你的心中，是你把它投射出去了，然后它又投射回

来，你又再投射出去，就这样的一直没完美了。结果这世界就充满了投射，充满了批判，对自己的批判，也对外在的批判。

The judgment and argument that you made, comes from the refraction of the heart. You think this are you, you think that you are your judge; you did not see that you are the diamond. You have been chasing everything outside, hope to calm down some judgments outside, but you don't know that the real judgment comes from your heart. You cast it out, then it is projected back, and you project it again. The process goes endlessly; making a world full of projections, full of criticism, criticism of oneself, and external criticism as well.

中断批判投射的方法只有一个，看见自己就是那批判投射的源头。回到钻石的内在，找回自己真正要发射出去的光，那光来自于宇宙的源头，来自于你心的源头，只要你连接上了你光的源头，你发射出来的就是纯粹的光，爱的光，爱的反射。

There is only one way to stop judgmental projection, that is seeing yourself is the source of that critical projection. Go back to the inner part of the diamond and find the light that you really want to project. The light comes from the origin source of the universe and comes from the source of your heart. As long as you connect to the source of your light, you will emit pure light that is the light of love and the reflection of love.

你就是那颗钻石。
You are the diamond.

白镜 White Mirror

白镜说，在镜子里你看到重重叠叠的你，那是你生生世世累计的面向。感觉它们，面对它们。他们都是你，你只能用爱去把它们串起来，合而为一。

White Mirror said that in the mirror you see the overlapping of you that is the cumulative faces of your life. Feel them, face them, they are you, you can only use love to string them together, and become One.

18. 白镜 White Mirror

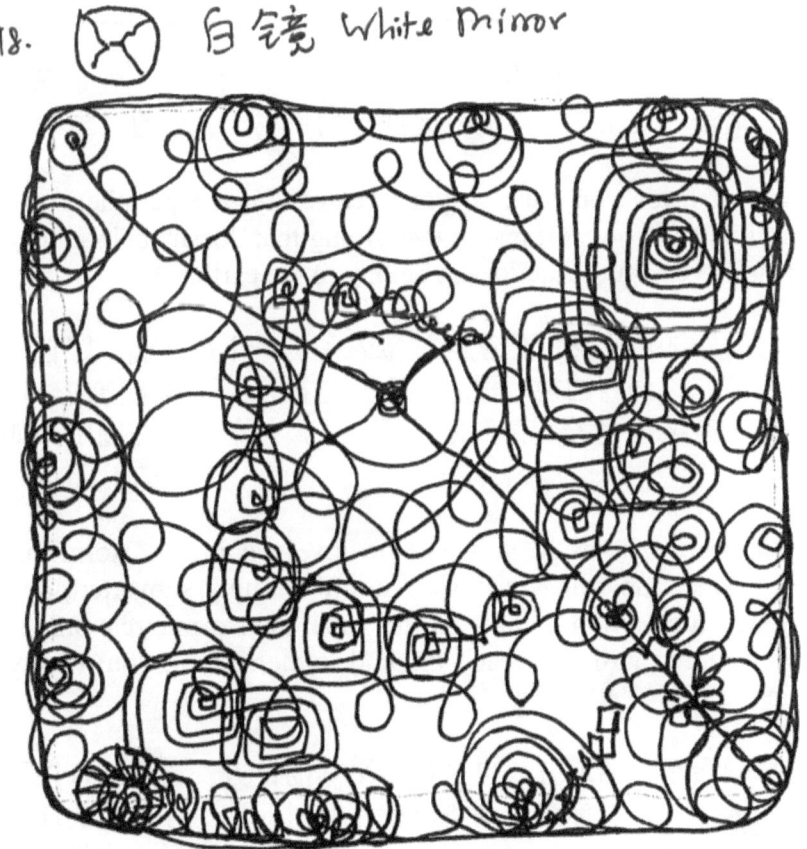

19. 蓝风暴 Blue Storm

蓝风暴 Blue Storm

那是风暴最平静的地方，也是你最平静的地方
That is the calmest place in the storm, and the place where you are the most calm.

风暴带领你回到自己的中心，在那捲起风暴的外围，它是那么的强烈，清洗一切不属于你的，清洗一切不属于大地的。

The storm leads you back to your centre. On the periphery of the storm, it is so strong, cleansing everything that doesn't belong to you, cleansing everything that doesn't belong to the earth.

你的心若跟随着它转，你就会被捲入了这一个风暴圈，跟自己失去了连接。你强烈的被颠覆着，不知道被带到了哪个方向。这时风暴圈唯有捲得更大，直到你到了尽头，想起了那在圈中如如不动的你。

If your heart follows it, you will be involved in this storm circle, losing connection with yourself. You are strongly subverted; do not know which direction to take. At this time, the storm circle only rolls up even more, until you reach the end, remembering you who were still in the circle.

那是风暴最平静的地方，也是你最平静的地方。这是你可以平息风暴的地方，只要你意识到自己就在此时此地。你再次的连接回自己，拿回自己的力量，外围的风暴慢慢的平息了。你仍在此时

此地，连接着你自己，连接着天与地。你知道风暴过后彩虹就会出现。

That is the calmest place in the storm, and the place where you are the most calm. This is the place where you can calm down the storm. As long as you realize that you are at the moment, you are connected back to yourself and get back your power. The storm slowly subsides. You are still at the moment, connecting to yourself, connecting to heaven and earth. You know that the rainbow will appear after the storm.

当你的心恢复了和谐，天地就恢复了和谐。一切就在你的心中，在你的意识的深处 那个旋涡的中心。

When your heart is restored to harmony, heaven and earth restore harmony。 Everything is in your heart, in the centre of the vortex that is deep in your consciousness,

你要去看见和连接它，让它形成了一道光，连接天与地，形成了一道光柱。你就在这光柱的中心， 带着爱往外散发你的光，形成一个向外旋转的光圈，光一直往外的扩散，你就在那中心，形成了一个太阳光，光芒万丈。

You must see it and connect to it, let it form a light, to connect the heaven and the earth, form a beam of light. And you are in the centre of the beam of light, emitting your light with love, forming an aperture that rotates outward. The light has spread all the way to the outside, and you are in the centre, forming a sun shining out.

感受这一道光，你就在中间，感受到这平静。这是来自你心的平静，是来自于爱的光，这爱创造了这世界的一切。

Feel the light; you are in the middle to feel the calm. This is the peace from your heart, the light from love, which creates everything in this world.

蓝风暴 Blue Storm

蓝风暴说，我急速的旋转着，你就在我的中心，感受着我的力度。 当你放下恐惧和期待， 你就能看清我。这是一个宽大维度的世界， 远远比你想象中的大。

Blue Storm said I am spinning fast; you are in my centre, feeling my strength. When you let go of fear and expectation, you can see me. This is a world of wide dimensions, far more bigger than you think.

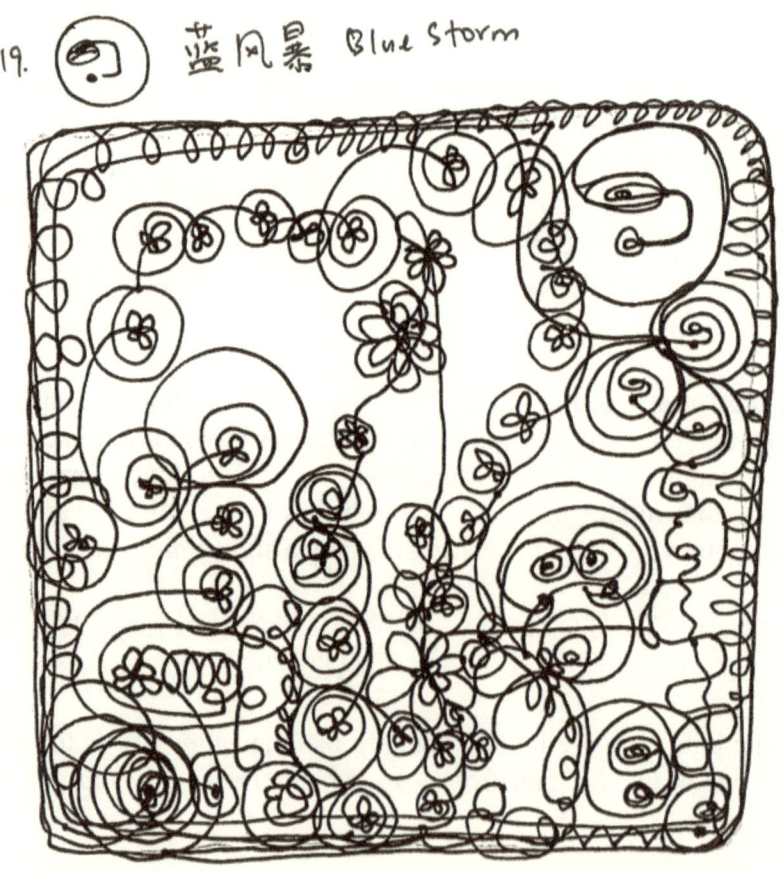

20. 黄太阳 Yellow Sun

黄太阳 Yellow Sun

成为你自己的太阳，你才能够成为别人的太阳和世界的太阳。
Be your own sun and you will be the sun of others and the sun of the world.

黄太阳的爱来自于照耀，照耀着每一个角落。它从不选择它所要照耀的对象，只是在默默的执行它的任务。它知道这一切是为了创造更美好的世界，一个更完整的世界，一个充满爱的世界。

The love of the Yellow Sun comes from shining; it is shining at every corner. It never chooses the object it wants to shine on, it just performs its task silently. It knows all this is for creating a better world, a more complete world and a world full of love.

它的给予是无条件的，但如果你的接收是有条件的，你无法完全吸收这养分。因为你是透过一层过滤膜而接收。你对这世界有条件的要求，你带着有条件的过滤网去投射它的爱，你无法在它的金光中旋转，你只能从它的金光中吸取你基本生活的养分。它提供的远远比你想象中多，但你无法一一的去理解和解码，因为你的认知停留在三次元。你无法看到更大的太阳。

Its giving is unconditional, but if your reception is conditional, you cannot fully absorb this nutrient, because you are receiving through a layer of filter. You have a conditional requirement for the world. You carry a conditional filter to cast its love. You can't rotate in its golden light. You can only absorb the nutrients of your basic life from its

golden light. It offers far more than you can think, but you can't understand and decode it one by one because your cognition stays in three dimensions. You can't see the bigger sun.

去连接这太阳的光，它会带你走向你的金光大道。让你看见更全面的自己，让你看见金光闪闪的自己。

Connect the light of the Sun; it will take you to your golden path. Let you see a more comprehensive self, let you see the glittering self.

太阳的光照耀着我的一切，我就是那太阳光。我利用这螺旋光的力量去成就我的一切，去照耀我的一切，我就是那光，我就是那太阳。我就是那照耀一切的源头。我有源源不绝的光，我有源源不绝的爱。当我成为发光体，我就是那太阳，我就是那给与众生无条件爱的太阳。我就是一切的中心。

The light of the sun shines on everything. I am the sun. I use the power of this spiral to accomplish everything, to shine on everything. I am the light, I am the sun. I am the source of everything that shines. I have an endless stream of light, I have endless love. When I become an illuminator, I am the sun; I am the sun that gives unconditional love to all beings. I am the center of everything.

我运用那源源不绝的光去为大地服务，也为自己服务。我就是你，你就是我。我们都是光，我们都是爱。让我们活在光中，活在爱中。

I use the endless light to serve the land and serve myself. I am you and you are me. We are all light, we are all love. Let us live in the light and live in love.

我们回归到了宇宙的源头 Hunab Ku
我们回归到了宇宙的源头 Hunab Ku
我们回归到了宇宙的源头 Hunab Ku

We returned to the origin source of the universe, Hunab Ku.
We returned to the origin source of the universe, Hunab Ku.
We returned to the origin source of the universe, Hunab Ku.

一切就是这样的螺旋旋转着。终点是原点，原点是终点，一切就这样的旋转着，不断的在进化，在提升。这就是我们的宇宙。用心去体会这一切，它就在你的心中。

Everything is like this spiral rotation. The end point is the origin, the origin is the end point, everything is rotating like this, constantly evolving and improving. This is our universe. Feel and understand this with your heart, it is in your heart.

看见这一切，带你走向爱的源头，觉悟的源头，就在这当下，我们临在的那一刻。看见你自己，你到底是谁。愿你的爱流传在世间，一代又一代，源源不绝。这就是太阳的光，太阳的爱。

Seeing all this, leading you to the source of love, the source of enlightenment, right now, at the moment we are there; seeing yourself and who you are. May your love be circulated in the world, from generation to generation. This is the light of the sun, the love of the sun.

成为你自己的太阳，你才能够成为别人的太阳和世界的太阳。找出你心中的太阳，让它先照耀你，温暖你，然后你自然就能成为一个发光体。把爱与光散发出去。这就是黄太阳。

Be your own sun and you will be the sun of others and the sun of the world. Find out the sun in your heart, let it shine on you and warm you first, and then you can naturally become an illuminator. Dissipate love and light. This is the Yellow Sun.

当一切回到平静，你也会渐渐回到你的中心，成为自己的光。在光中你消融了自己，也消融了这世界。重回到了宇宙的子宫。你是爱，你是光。你就是这一切。

When everything returns to calmness, you will gradually return to your center and become your own light. In the light you become one with yourself and you become one with the world. You are returning to the uterus of the universe. You are love, you are light. You are all this.

黄太阳 Yellow Sun

太阳说，我的光温暖了你，温暖了整个世界，我就在上方，我的光旋转着放射出去。 看见宇宙，看见我。

The sun said, my light warms you, warms the whole world, I am above, and my light was spinning out. Seeing the universe and seeing me.

20. 黄太阳 Yellow Sun

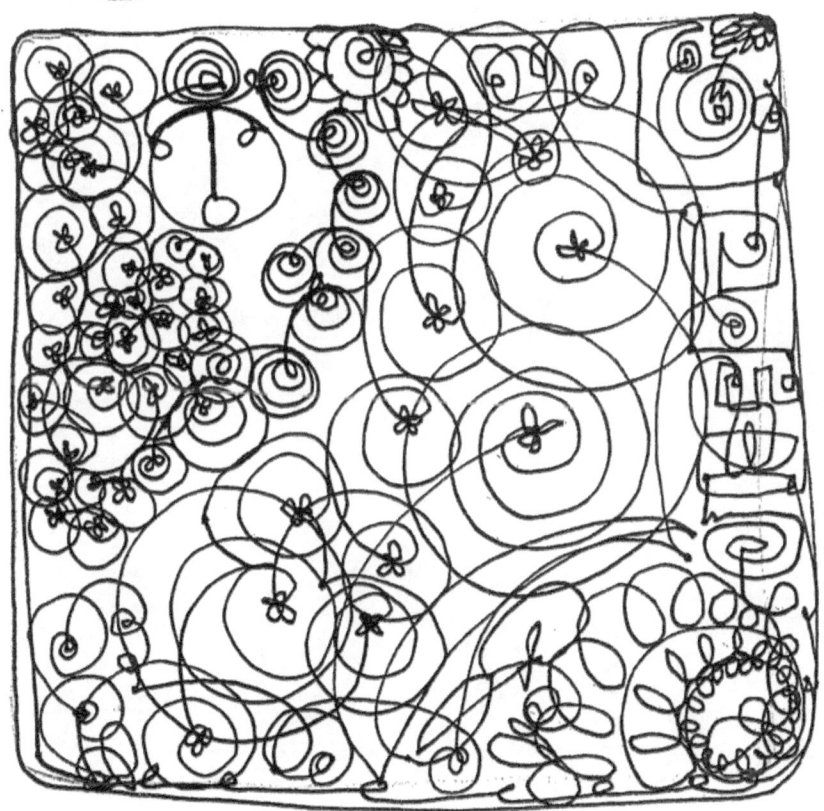

21. Hunab Ku 银河中心

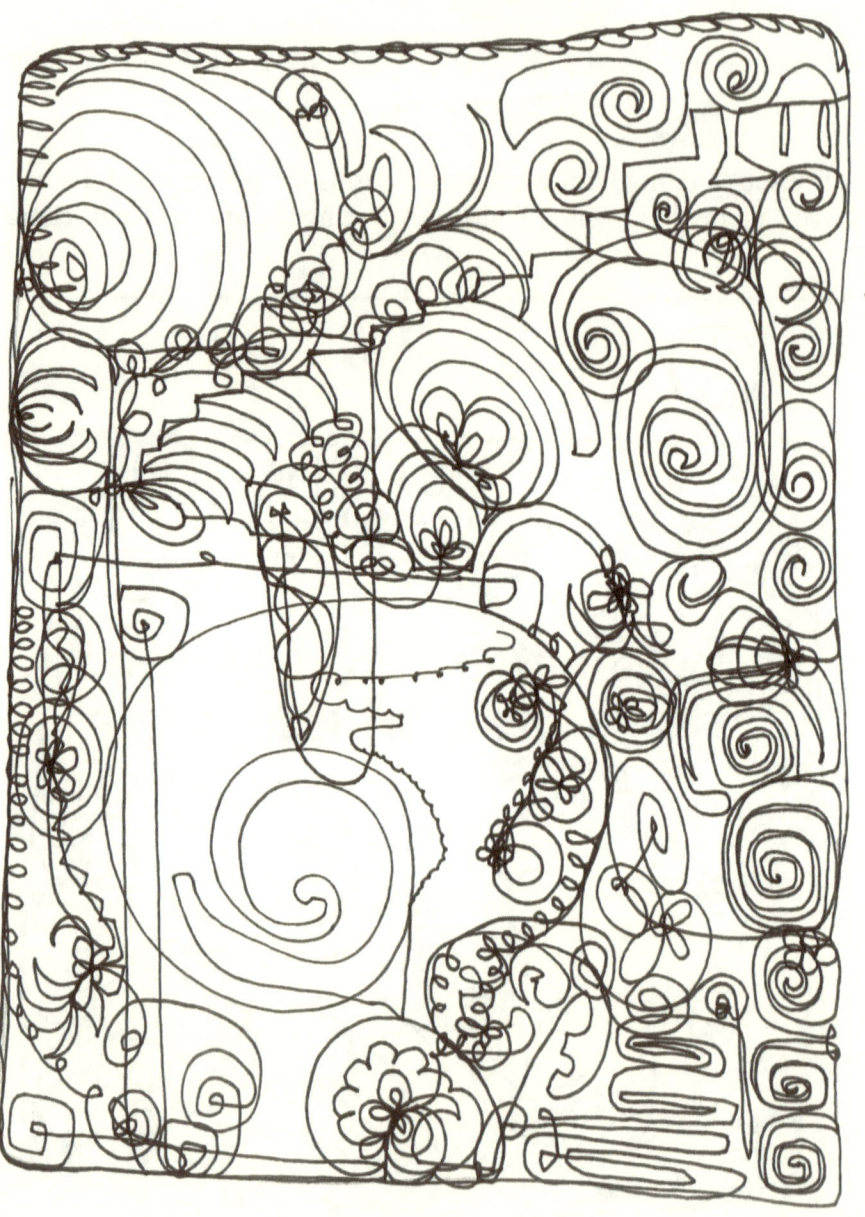

22. 20个太阳图腾 20 solar Seals

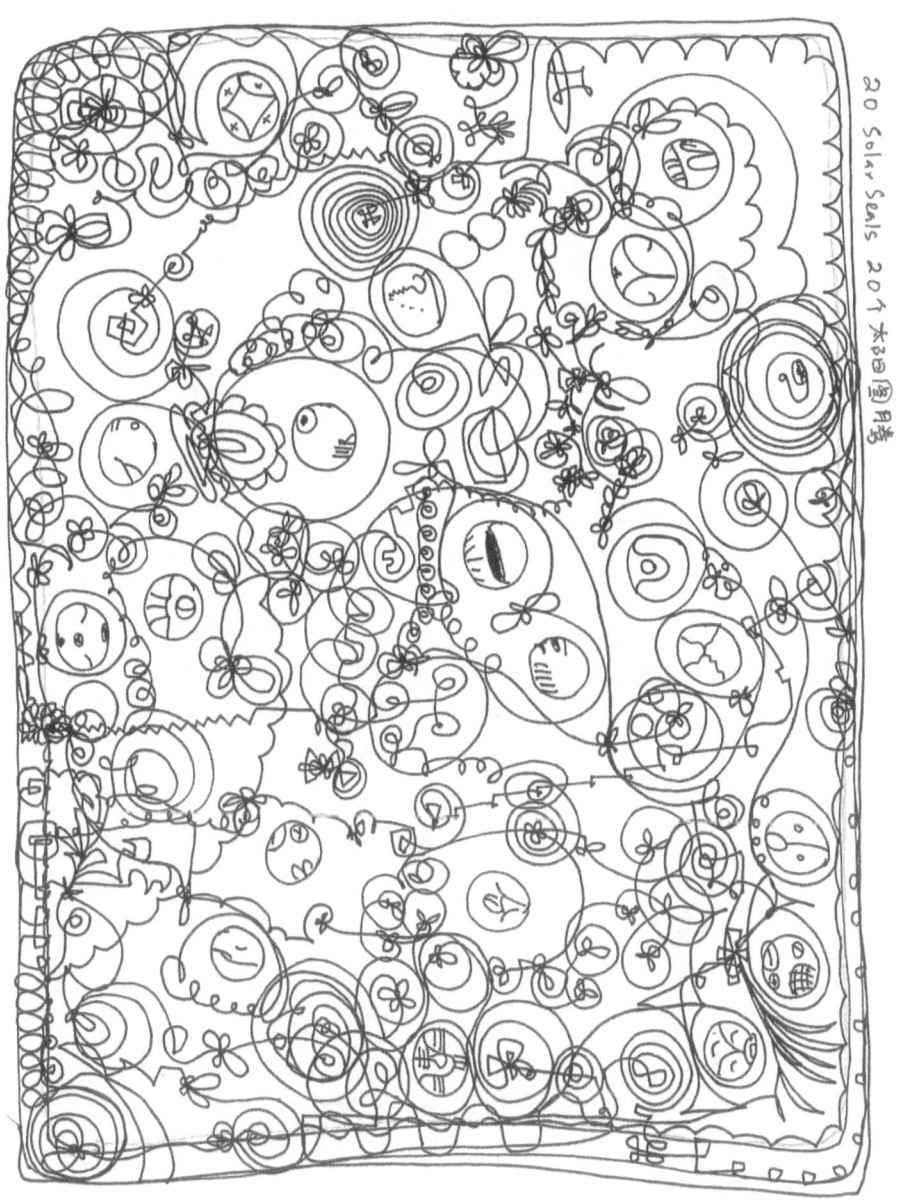

23. 20个 太阳波符 20 Wavespells
23.1　红龙波符 Red Dragon Wavespell

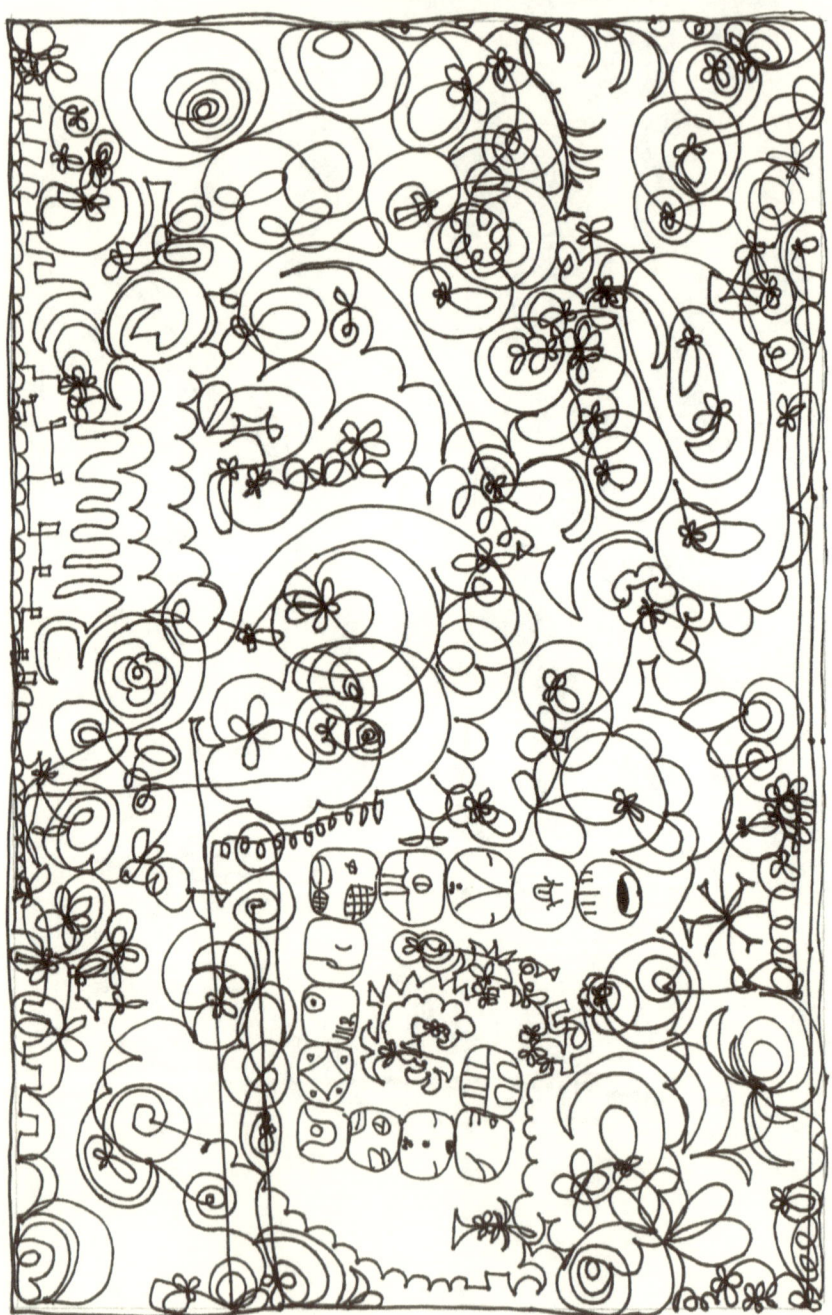

23.2 白巫师波符 White Wizard Wavespell

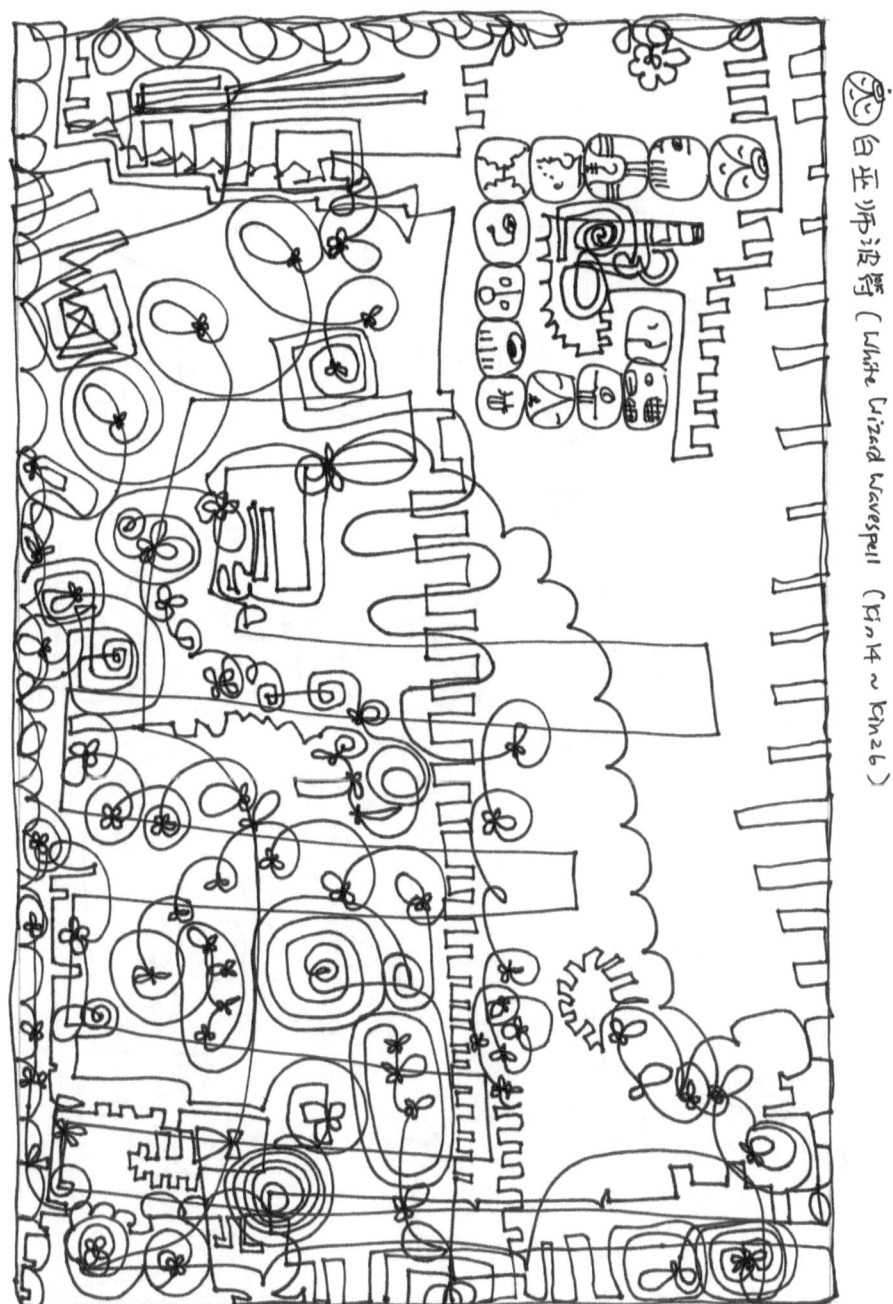

23.3 蓝手波符 Blue Hand Wavespell

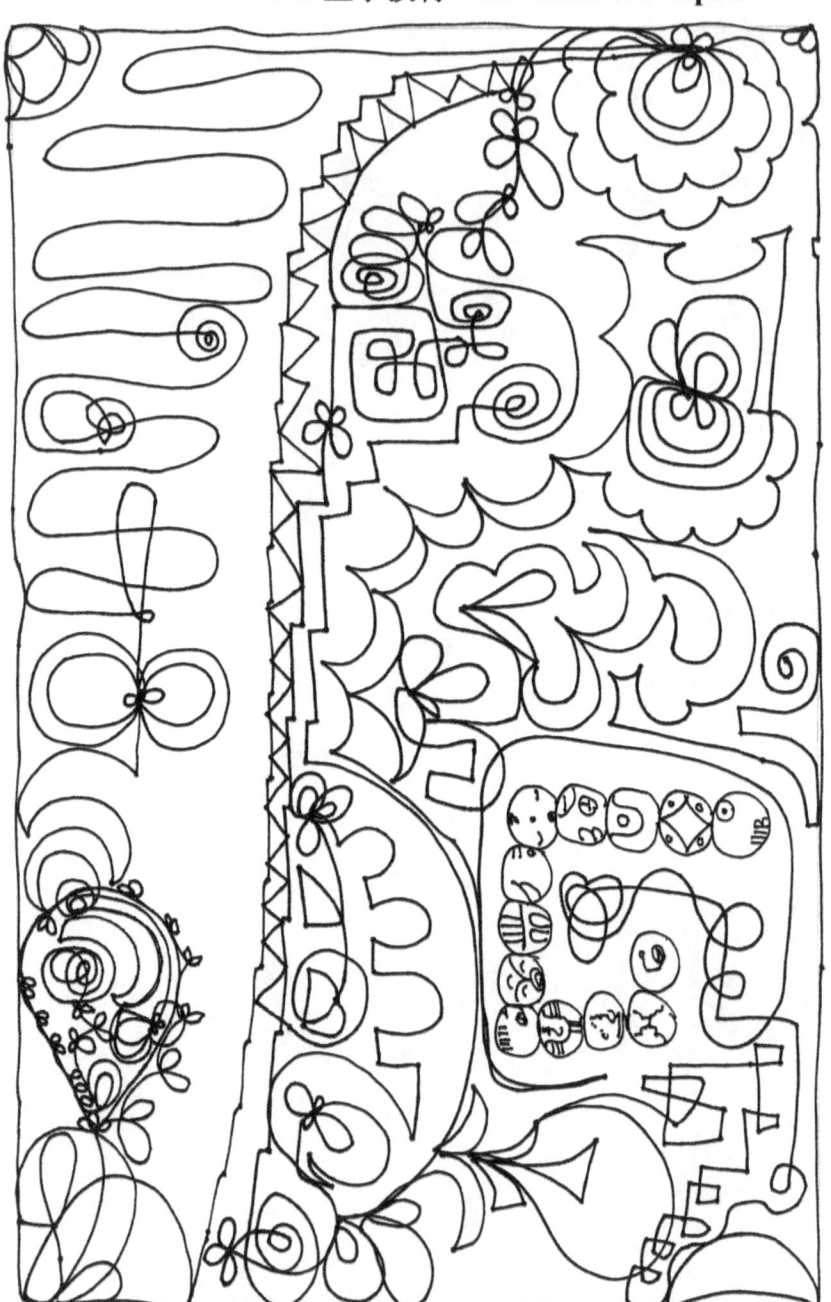

23.4 黄太阳波符 Yellow Sun Wavespell

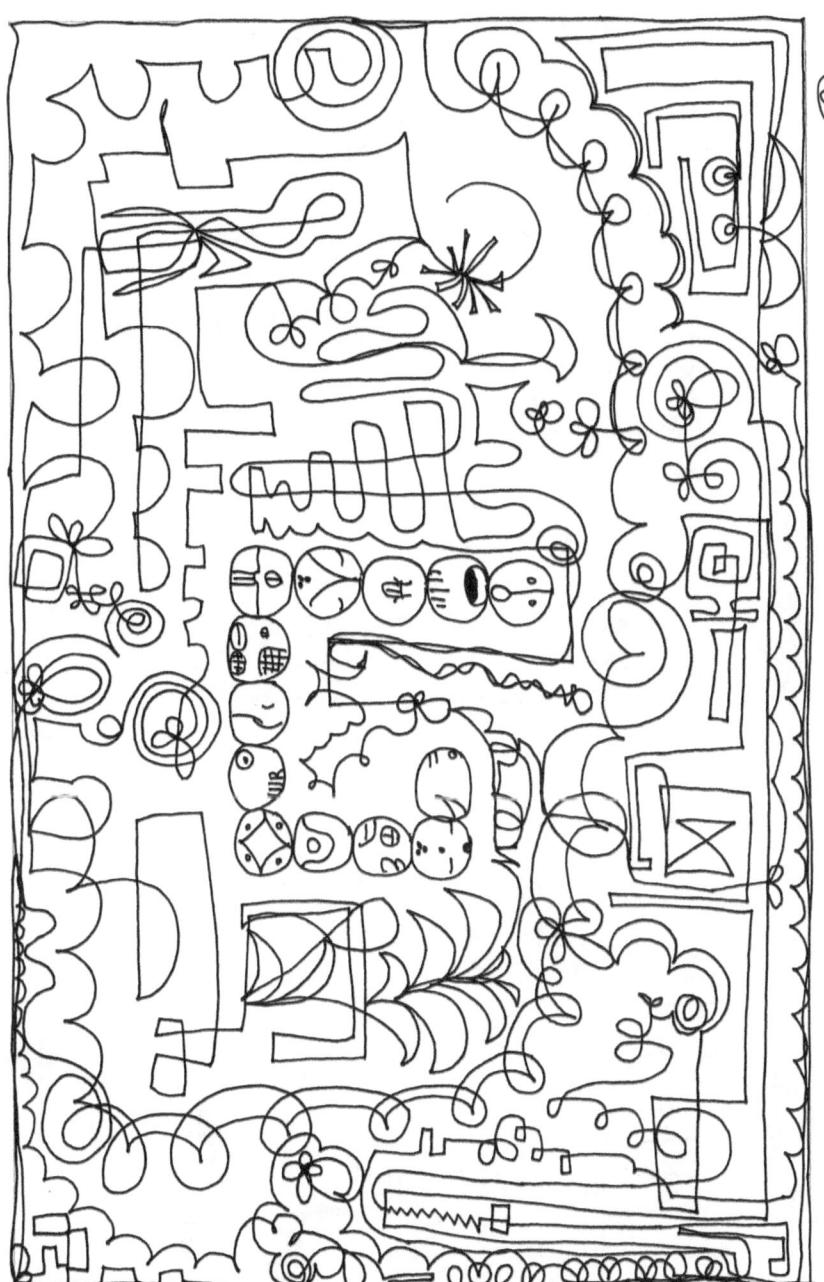

23.5 红天行者波符 Red Sky Walker Wavespell

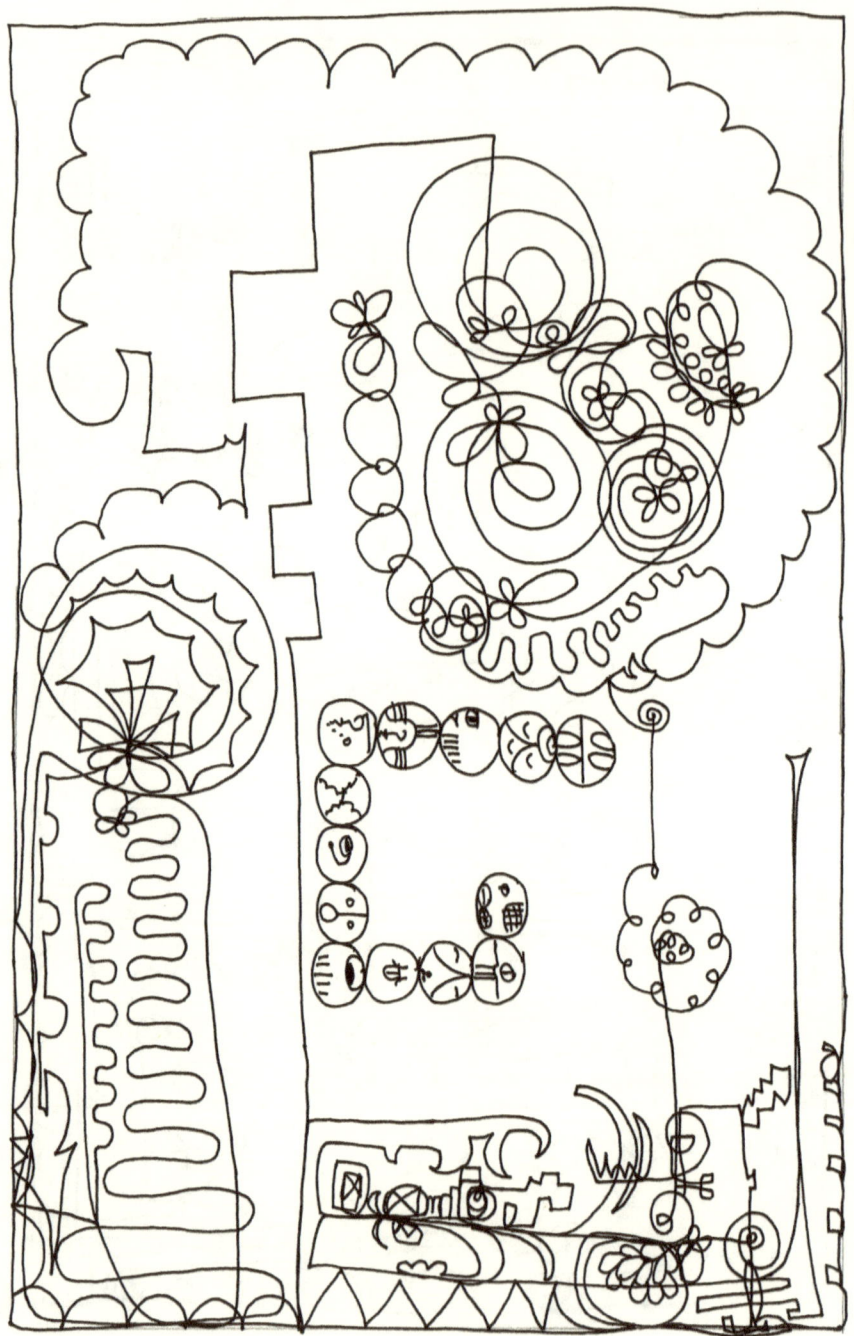

23.6 白世界桥波符 White World Bridger Wavespell

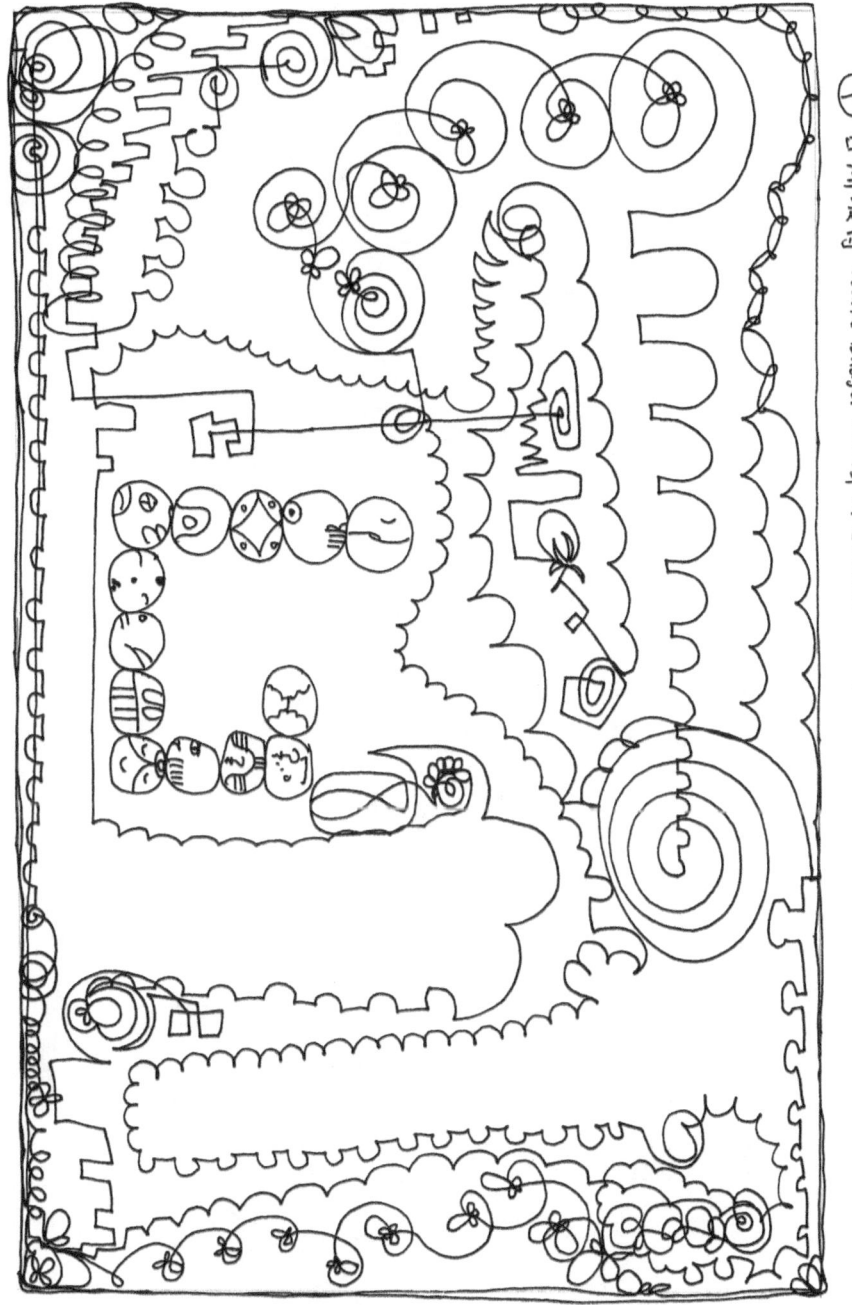

23.7 蓝风暴波符 Blue Storm Wavespell

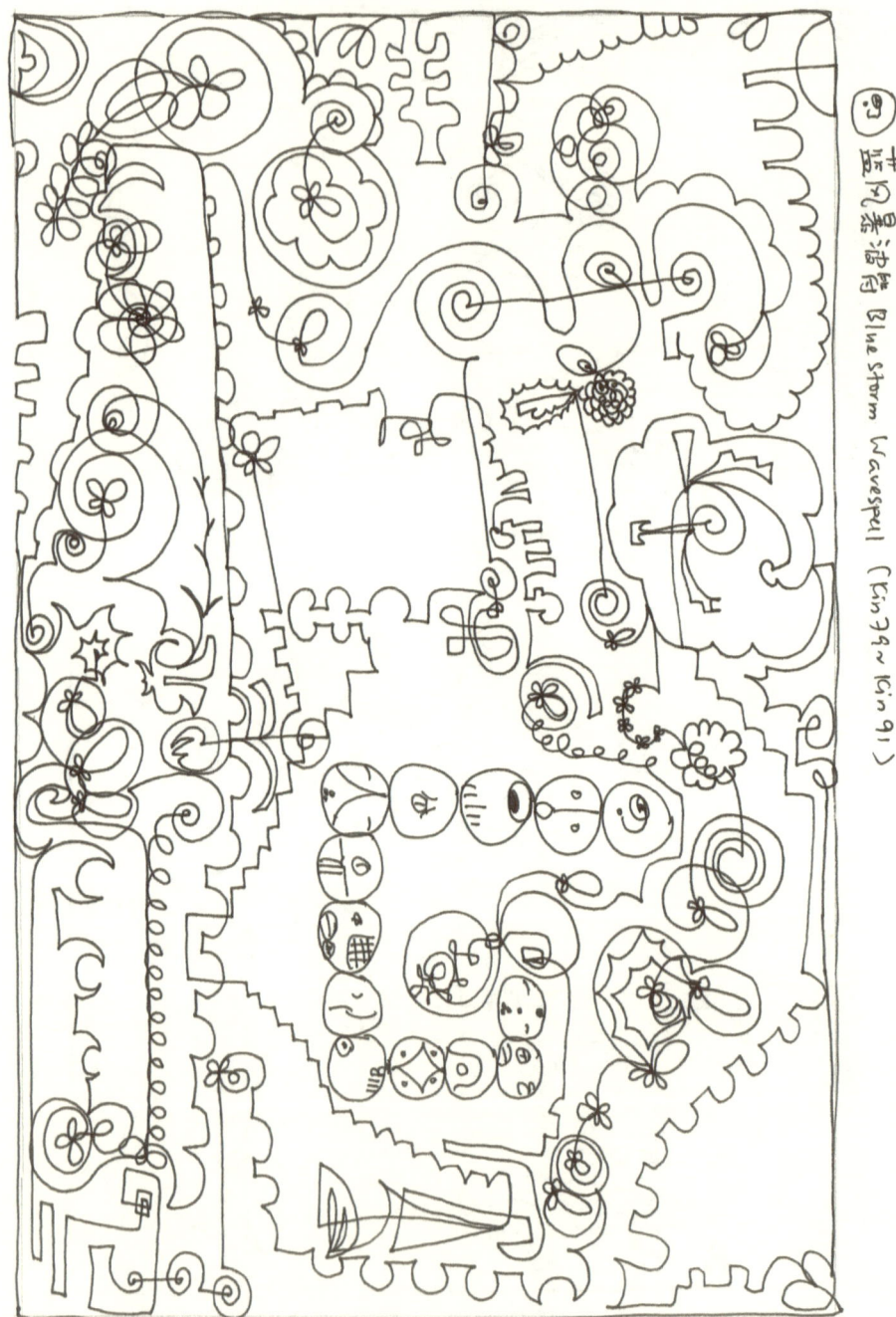

23.8 黄人波符 Yellow Human Wavespell

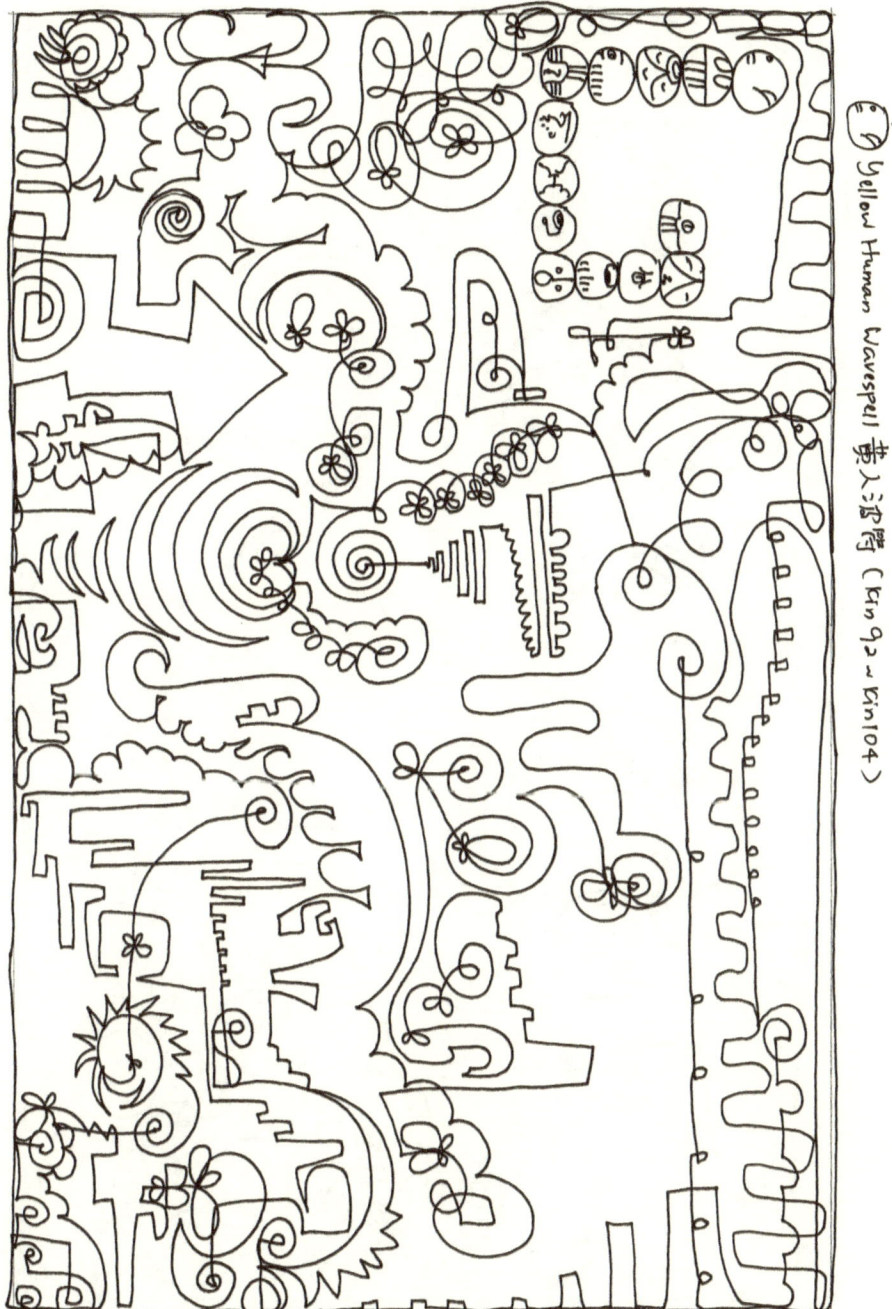

23.9 红蛇波符 Red Serpent Wavespell

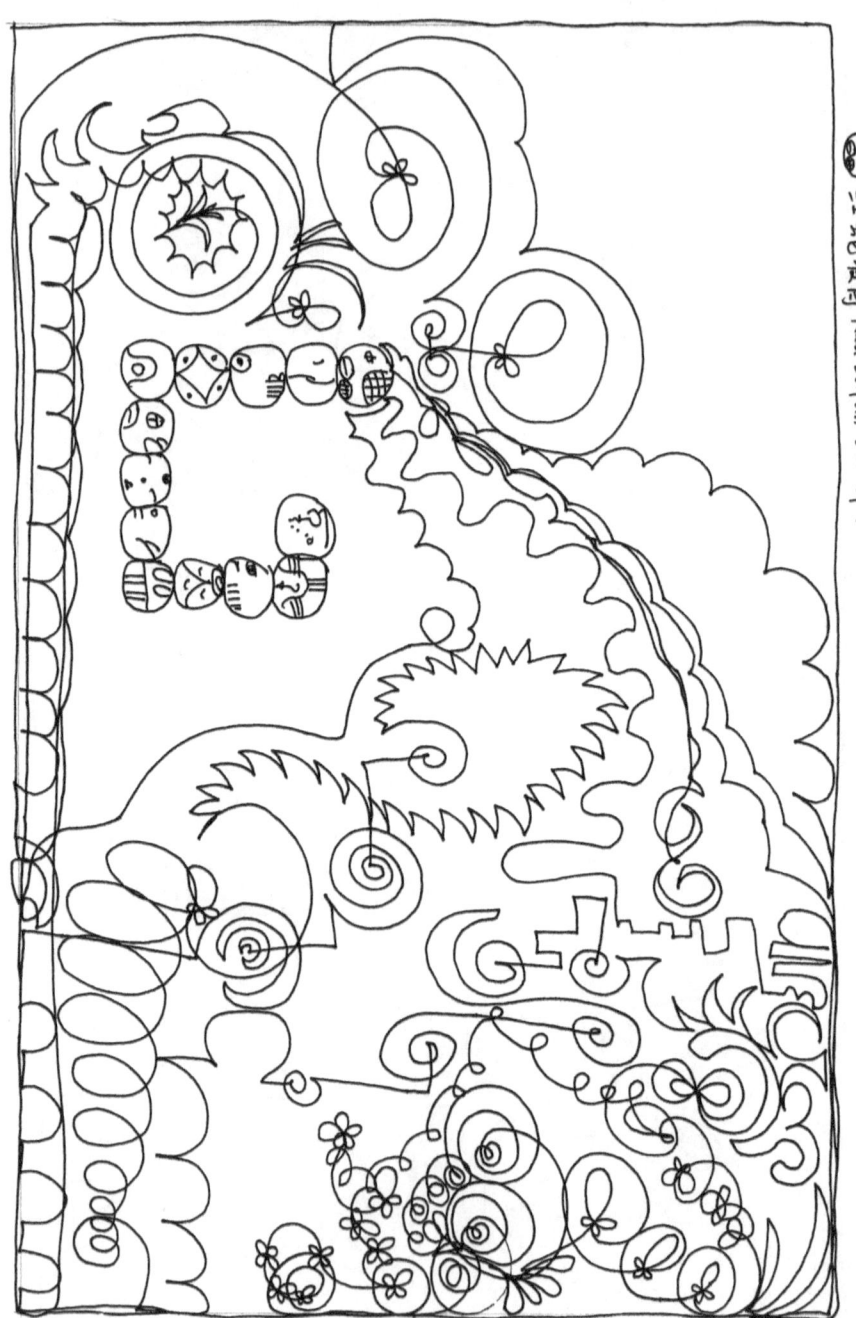

23.10 白镜波符 White Mirror Wavespell

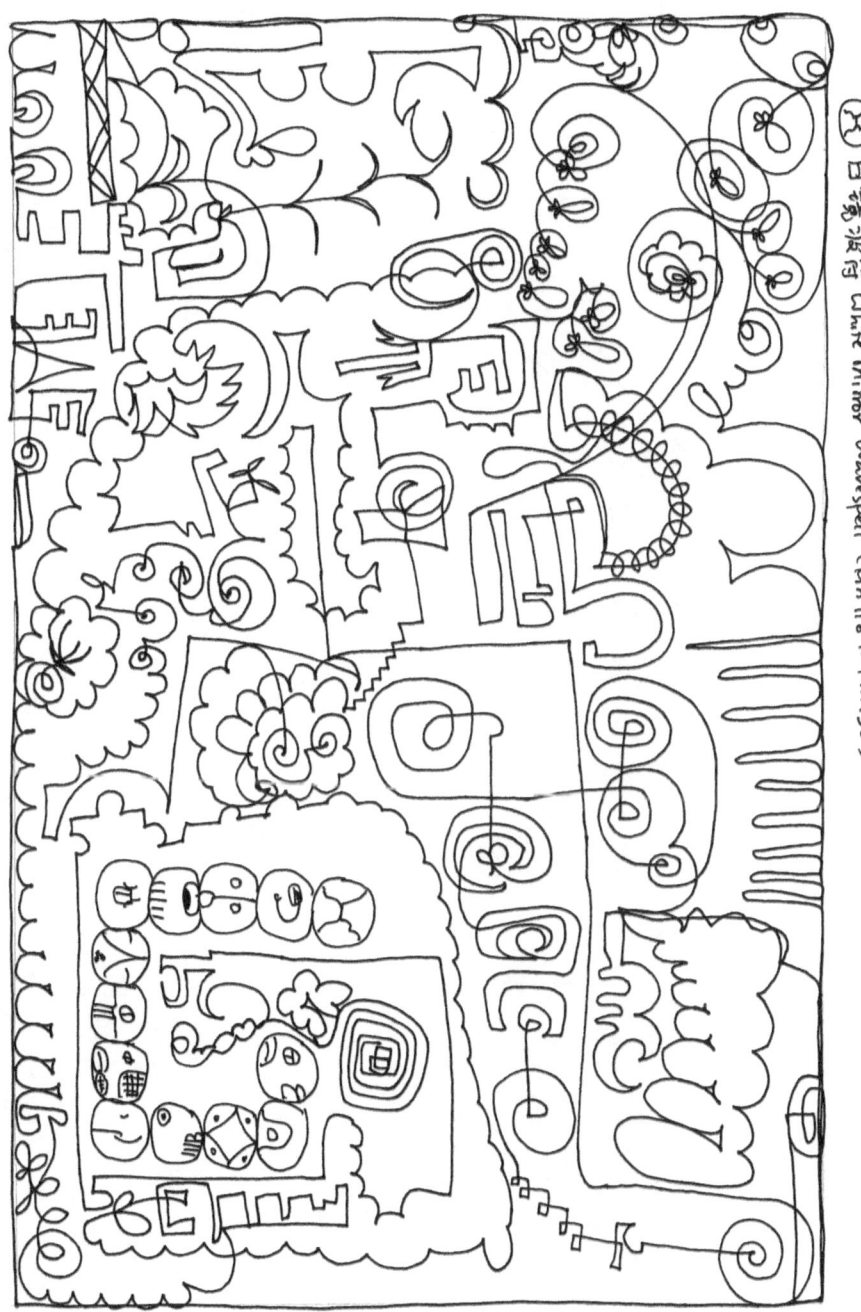

23.11 蓝猴波符 Blue Monkey Wavespell

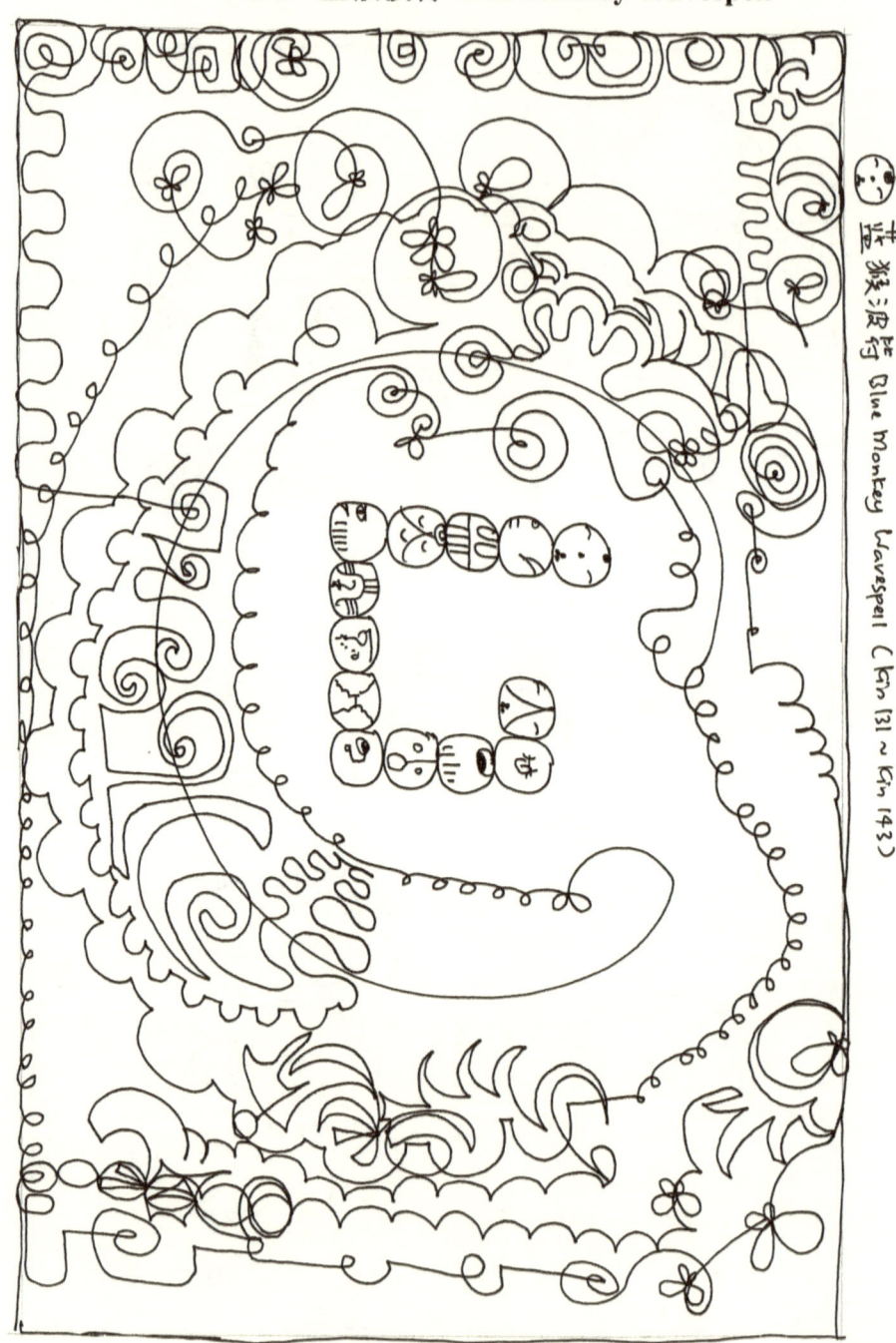

23.12 黄种子波符 Yellow Seed Wavespell

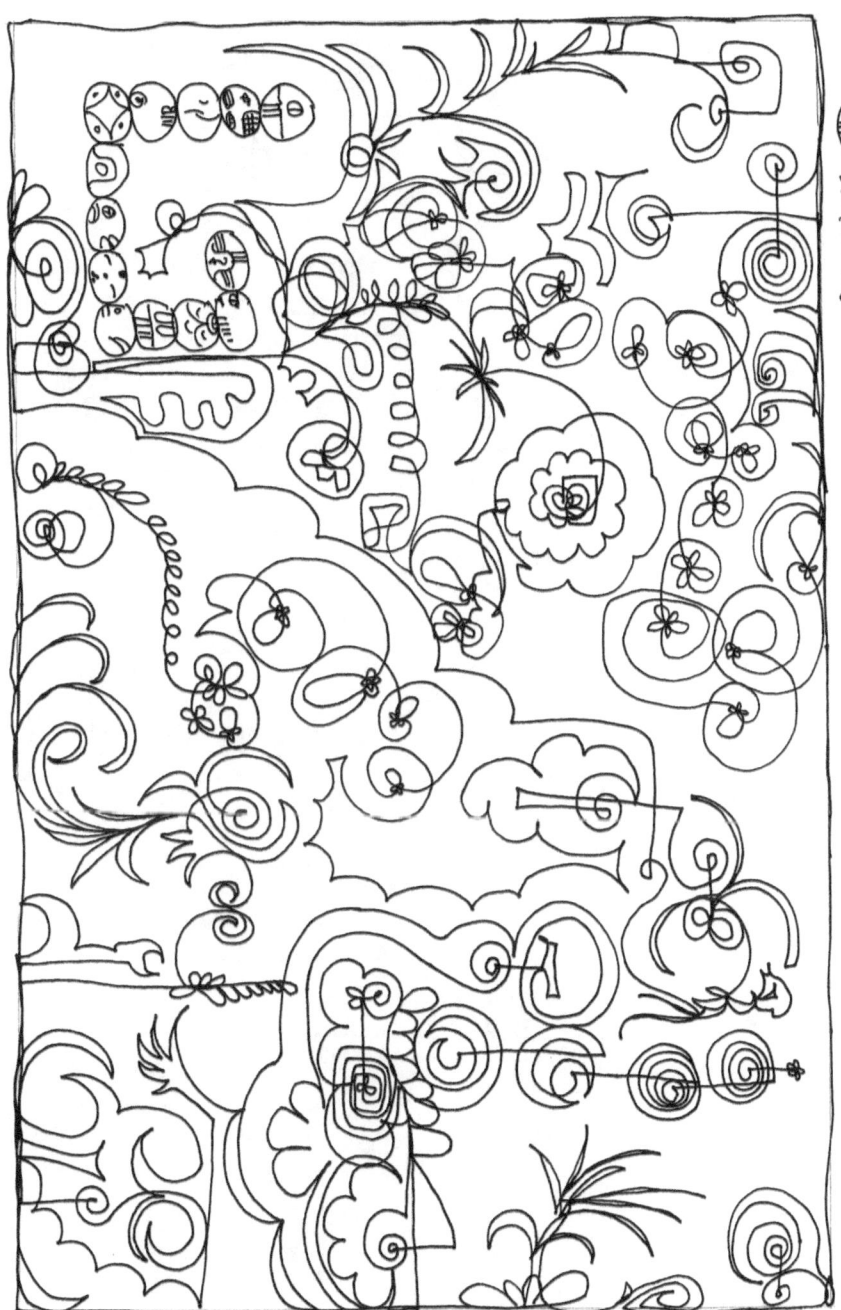

23.13 红地球波符 Red Earth Wavespell

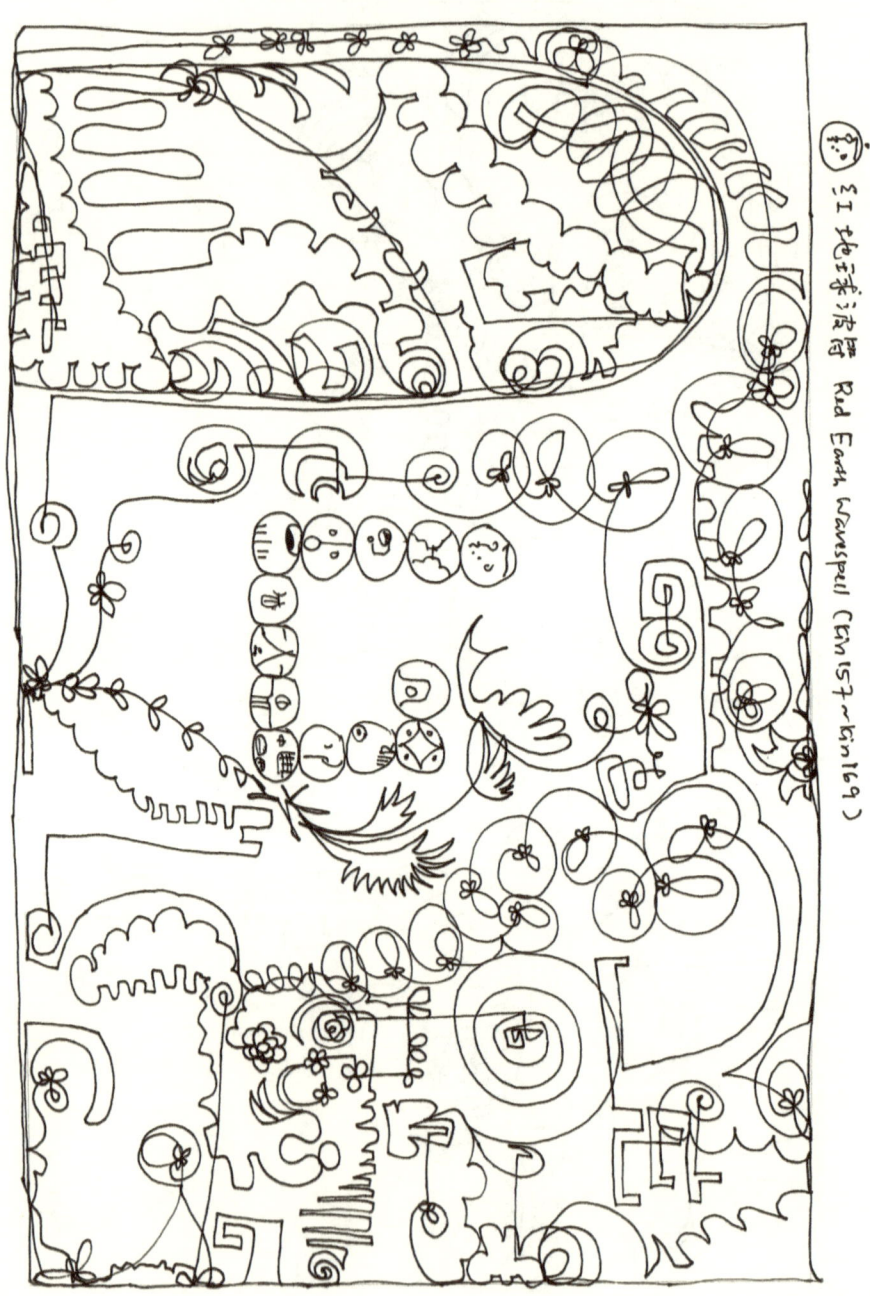

23.14 白狗波符 White Dog Wavespell

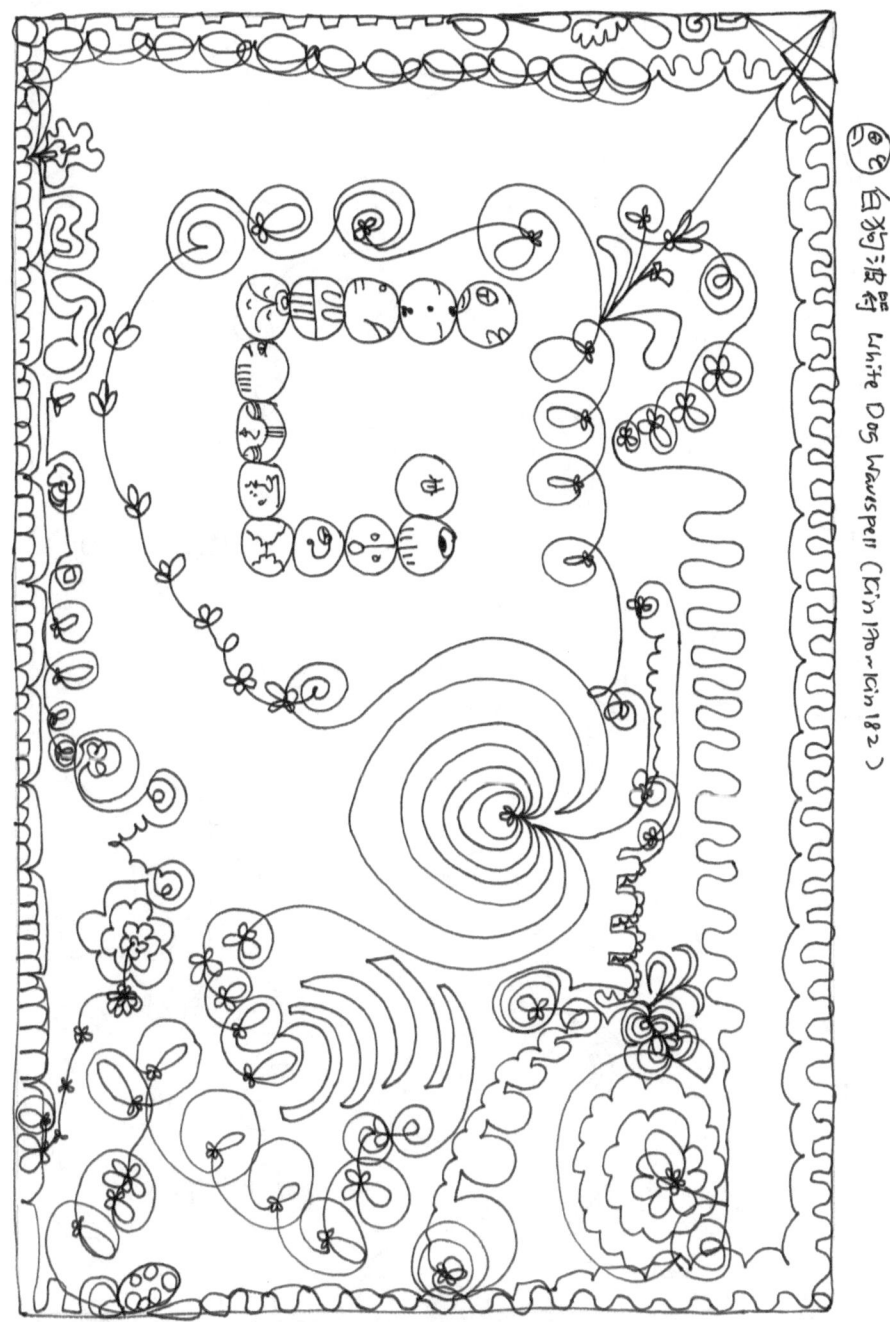

23.15 蓝夜波符 Blue Night Wavespell

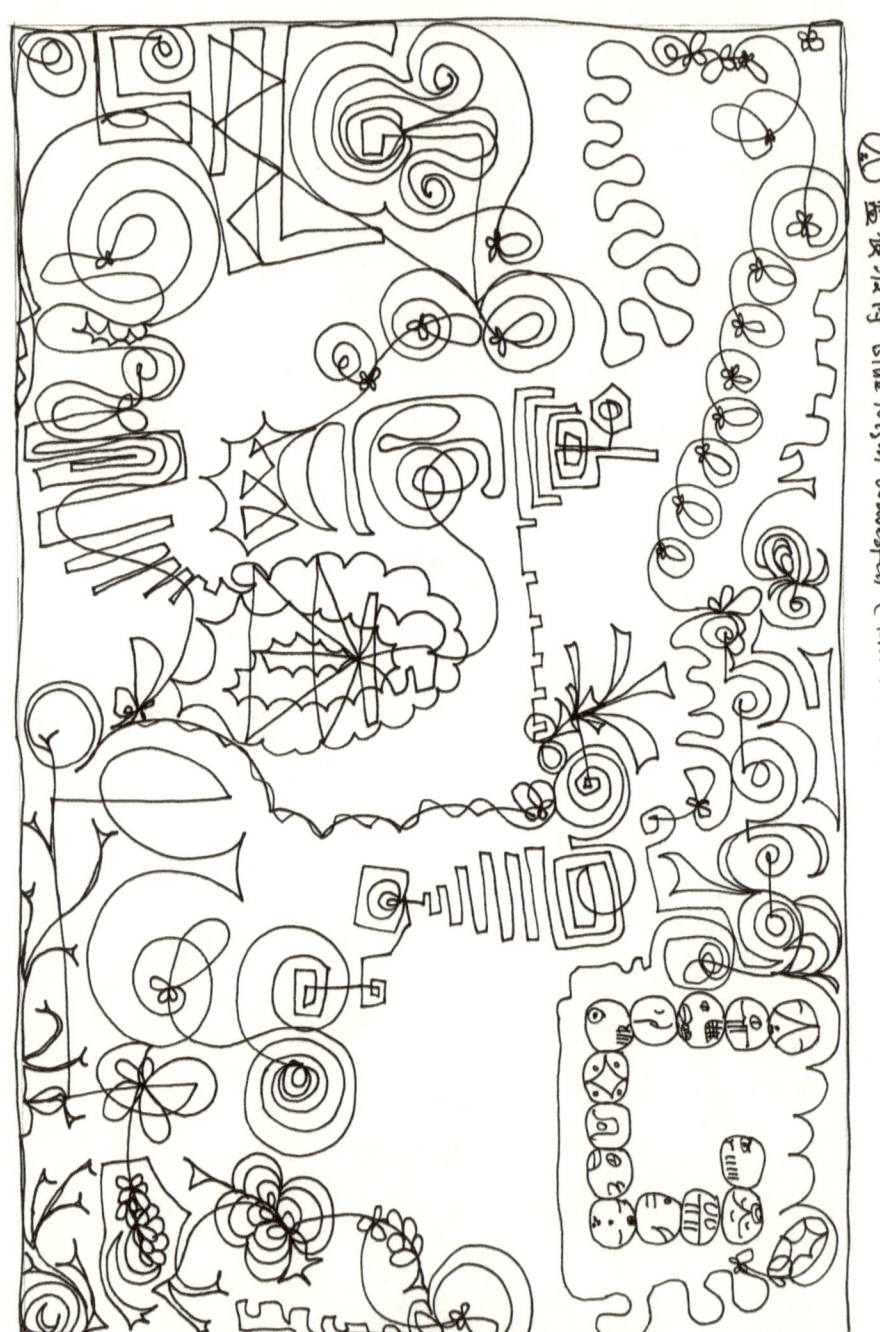

23.16 黄战士波符 Yellow Warrior Wavespell

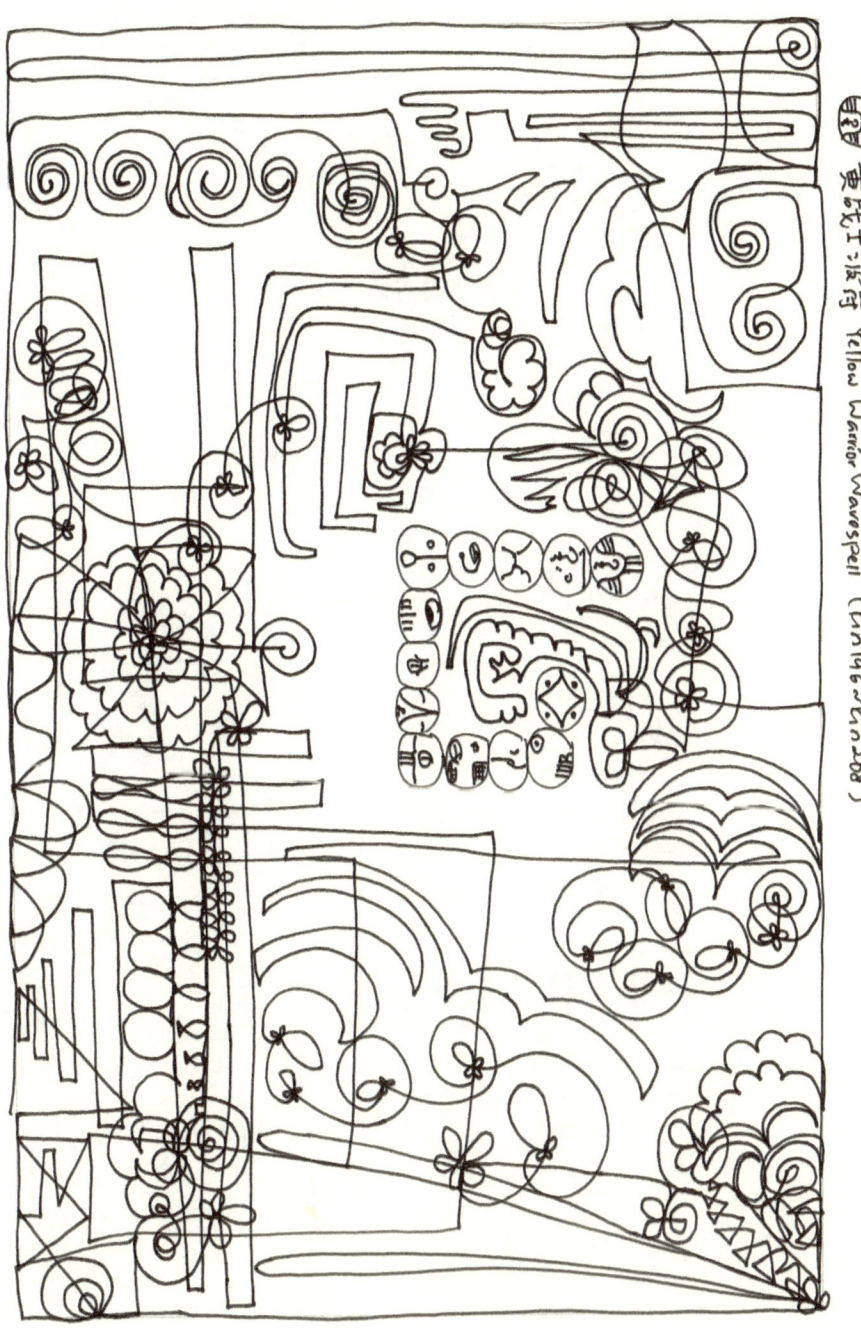

23.17 红月波符 Red Moon Wavespell

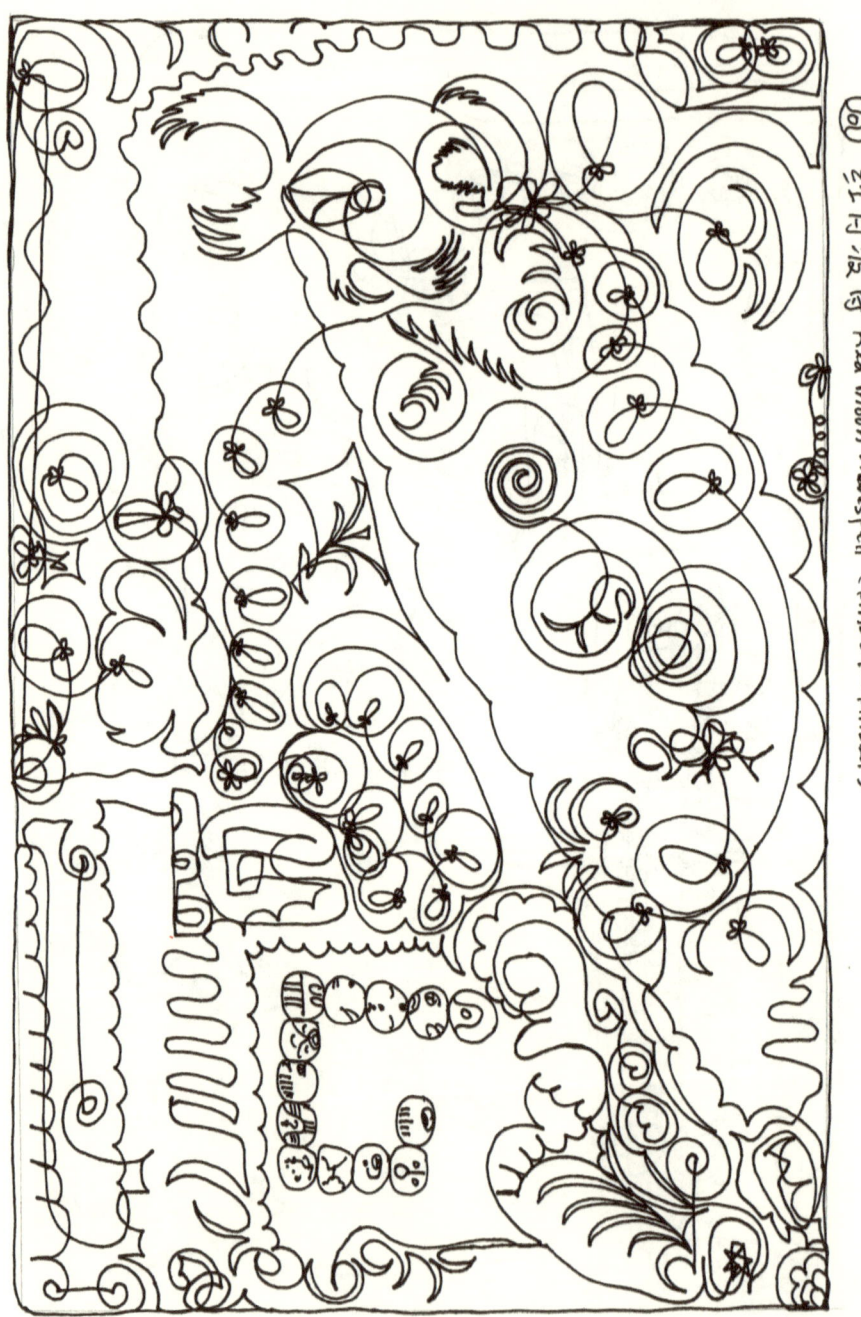

23.18 白风波符 White Wind Wavespell

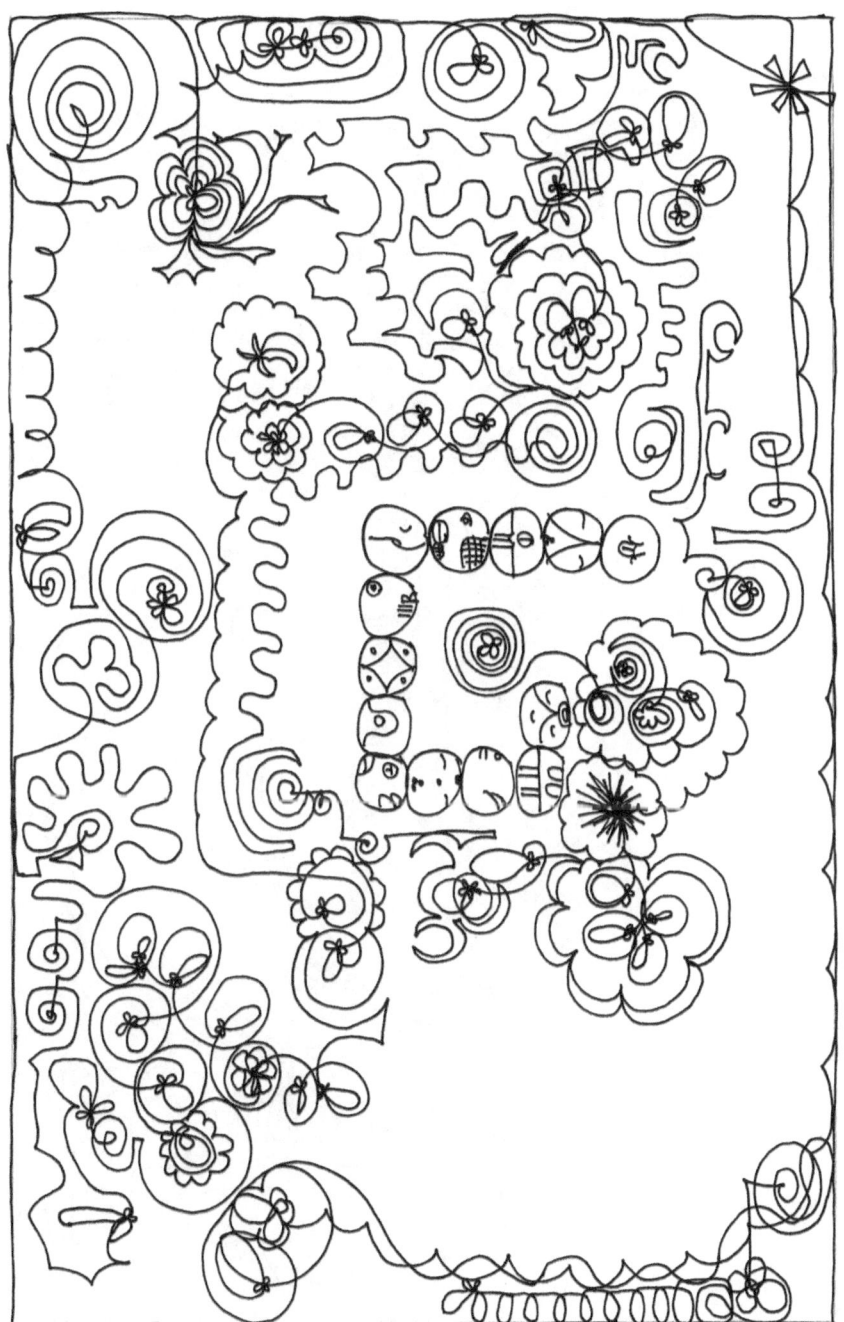

23.19 蓝鹰波符 Blue Eagle Wavespell

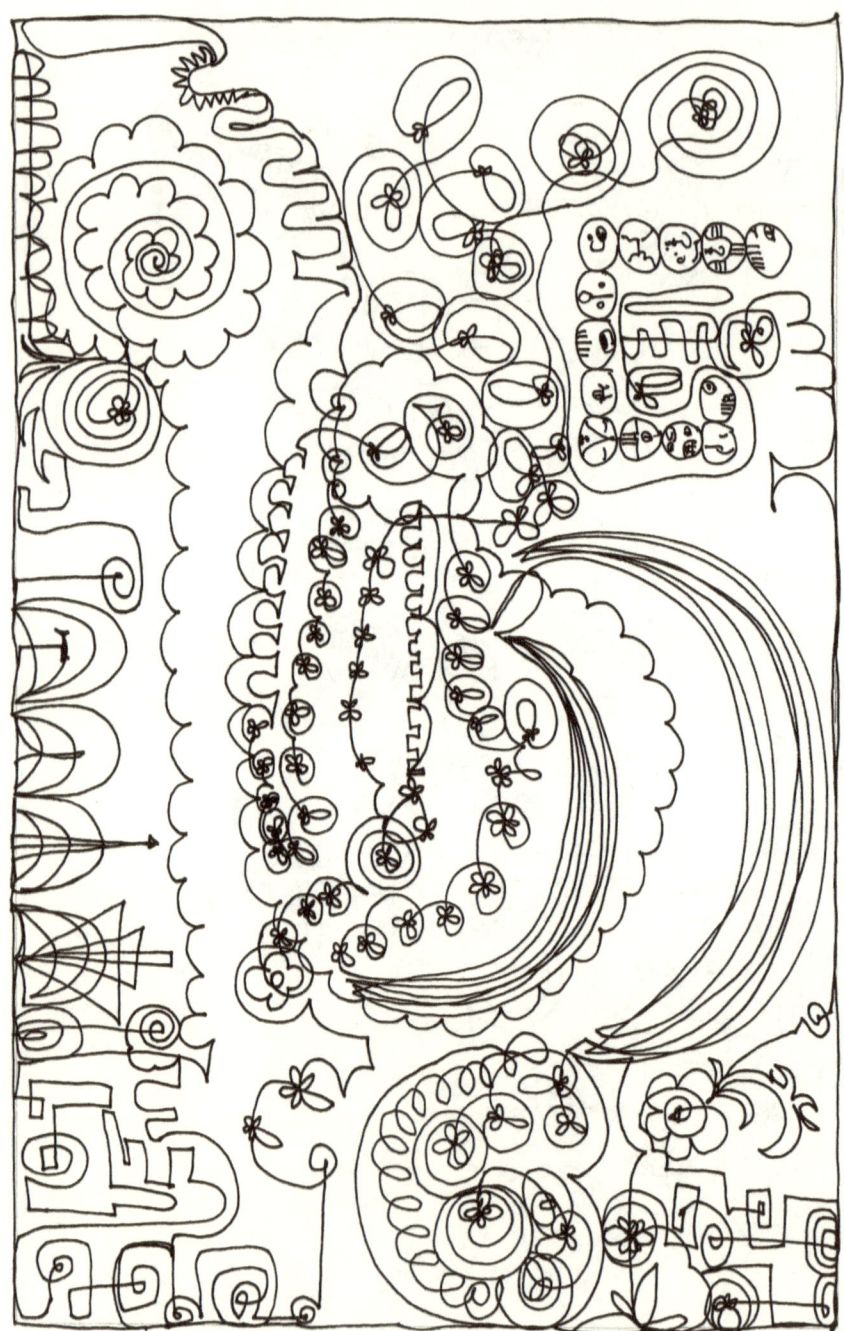

23.20 黄星星波符 Yellow Star Wavespell

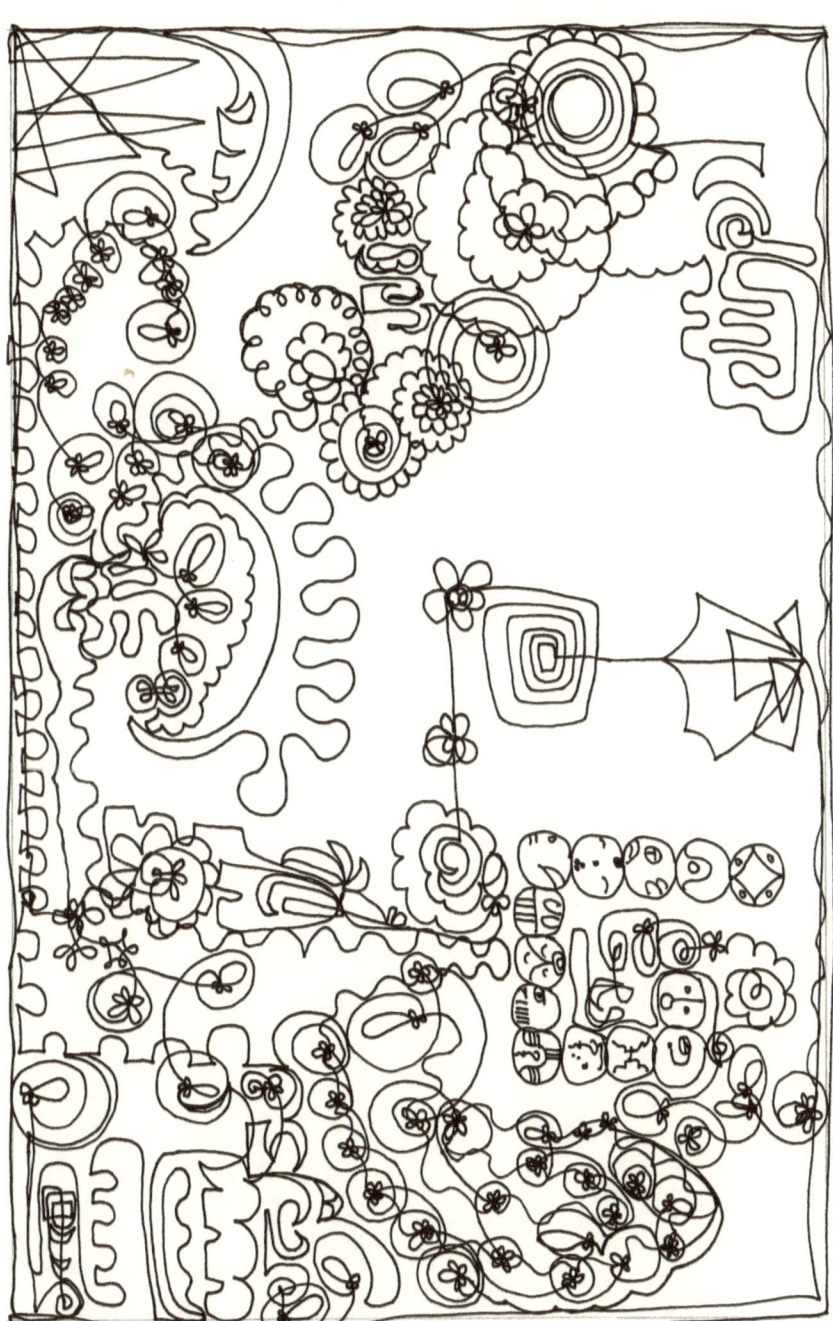